W9-ACW-231

★★★ THE ★★★
ILLUSTRATED FEMINIST

How important it is for us to recognize
and celebrate our heroes and she-roes!

MAYA ANGELOU

Editors: Ashley Albert and Madeline Jaffe
Designer: Diane Shaw
Production Manager: Rebecca Westall

Library of Congress Control Number:
2019939760

ISBN: 978-1-4197-4211-8
eISBN: 978-1-68335-888-6

Printed and bound in China
10 9 8 7 6 5 4 3 2 1

Abrams Image books are available at
special discounts when purchased in quantity
for premiums and promotions as well as
fundraising or educational use. Special editions
can also be created to specification. For details,
contact specialsales@abramsbooks.com or the
address below.

Abrams Image® is a registered trademark of
Harry N. Abrams, Inc.

ABRAMS The Art of Books
195 Broadway, New York, NY 10007
abramsbooks.com

★★★ THE ★★★ ILLUSTRATED FEMINIST

100 Years of Suffrage, Strength, and Sisterhood in America

BY AURA LEWIS

ABRAMS IMAGE, NEW YORK

★ Contents ★

Introduction: Welcome to *The Illustrated Feminist!* 8

CHAPTER 1: 1920S
THE ROARING TWENTIES / 10

1920	Votes for Women! The Nineteenth Amendment	13
1921	Women's Welfare and Health Care: The Sheppard-Towner Maternity and Infancy Act	14
1921	Sadie Tanner Mossell Alexander: First African American Woman to Earn a Ph.D.	19
1921	Margaret Sanger and the American Birth Control League	18
1921	Kotex: The First Commercially Available Disposable Sanitary Napkin	20
1922	The Flappers: The Party Women of the Jazz Age	21
1925	Florence Sabin: First Lady of American Science	22
1925	Nellie Tayloe Ross: First Female Governor	23
1926	Gertrude Caroline Ederle: Queen of the Waves	26
1928	Clara Bow: The Original It Girl	27

CHAPTER 2: 1930S
PIONEERS / 28

1930	Women in Hard Times: The Great Depression	31
1931	Jane Addams: First American Woman to Receive the Nobel Peace Prize	32
1932	Amelia Earhart: First Lady of the Sky	35
1932	Hattie Wyatt Caraway: First Woman Elected to the Senate	36
1933	Eleanor Roosevelt: A New Kind of First Lady	39
1934	Lettie Pate Whitehead Evans: First Female Board Member of a Major Corporation	40
1935	The National Council of Negro Women	42
1936	Margaret Mitchell's *Gone with the Wind*	43
1936	Contraception Is Legalized	44
1939	Karen Horney and Feminine Psychology	45

CHAPTER 3: 1940S
WOMEN AT WORK / 46

1940–1945	Women and World War II	50
1941	The "Computers" of Langley Memorial Aeronautical Laboratory	51
1941	Wonder Woman: Goddess of Love and War	53
1942	Rosie the Riveter: "We Can Do It!"	54
1942	Women in the Military: WAC, WAVES, SPARS, WR, and WASP	57
1942	Annie Gayton Fox: First Woman to Receive the Purple Heart	58
1943	A League of Their Own: The AAGPBL	59
1944	*Seventeen* Magazine	62
1947	Lundberg & Farnham's *Modern Woman: The Lost Sex*	65
1948	Alice Marie Coachman: First Black Female Olympic Gold Medalist	66

CHAPTER 4: 1950S
MOMENTUM, BACKLASHES, AND EYELASHES / 68

1950	The New Cult of Domesticity	71
1950	*The Hazel Scott Show*	72
1951	Christine Jorgensen and Transgender Advocacy	74
1953	*Playboy* Magazine: Sexy or Sexist?	75
1955	Rosa Parks: First Lady of Civil Rights	77
1955	Doris Day: The Girl Next Door	78
1955	The Daughters of Bilitis: First Lesbian Civil and Political Rights Organization	81
1956	La Leche League International: Breast Is Best	82
1959	Barbie: More Than a Doll	83
1959	Lorraine Hansberry: "To Be Young, Gifted, and Black"	84

CHAPTER 5: 1960S
WE WANT A REVOLUTION! / 86

1960	Enovid: aka The Pill	88
1961	The President's Commission on the Status of Women	89
1962	Helen Gurley Brown's *Sex and the Single Girl*	91
1963	Betty Friedan's *The Feminine Mystique*	93
1963	The Equal Pay Act	94
1964	The Civil Rights Act	95
1967	Kathrine Switzer: She Should Run	99
1968	The Feminist Protest at the Miss America Pageant: "All Women Are Beautiful!"	101
1968	Shirley Chisholm: "Unbossed and Unbought"	103
1969	The Redstockings: Sisterhood Is Powerful	104

CHAPTER 6: 1970S
THE SECOND WAVE IN FULL SWING / 106

1970	*The Mary Tyler Moore Show*: "TV's First Truly Female-Dominated Sitcom"	108
1970	Women's Strike for Equality	109
1970	Mujeres de Corazón: The Comisión Femenil Mexicana Nacional	112
1971	*Ms.* Magazine	113
1973	*Roe v. Wade*: My Body, My Choice	115
1973	Billie Jean King and the Battle of the Sexes	116
1974	Money of Her Own: The Equal Credit Opportunity Act	119
1975	A Jury of Her Peers	120
1976	Sarah Caldwell: "Music's Wonder Woman"	122
1978	The Pregnancy Discrimination Act	123

CHAPTER 7: 1980S
POSTFEMINISM / 124

1980	Herstory: National Women's History Week	127
1983	Alice Walker and Womanism	128
1983	Sally Ride: First Woman in Space	131
1983	Madonna: Queen of Pop	132
1984	Geraldine Ferraro: "Some Leaders Are Born Women"	134
1984	Audre Lorde's *Sister Outsider*	135
1985	Guerrilla Girls: Reinventing the "F" Word	137
1985	Wilma Mankiller: First Female Chief of the Cherokee Nation	138
1985	EMILY's List: Early Money Is Like Yeast	141
1989	The Great Crossover: Age of Marriage > Age of First Child	142

CHAPTER 8: 1990S
THE THIRD WAVE / 144

1990	Judith Butler's *Gender Trouble*	147
1991	*Thelma & Louise*	148
1991	Riot Grrrls	151
1991	Anita Hill and Sexual Harassment Awareness	152
1992	Year of the Woman	154
1992	Carol Elizabeth Moseley Braun: First African American Woman Elected to the Senate	156
1992	*Murphy Brown*: "Families Come in All Shapes and Sizes"	157
1993	*The Joy Luck Club*	158

1993 Toni Morrison: First African American Woman to Win the Nobel Prize
in Literature 161
1996 Eve Ensler's *The Vagina Monologues* 162

CHAPTER 9: 2000S
THE NEW MILLENNIUM / 164

2000 bell hooks's *Feminism Is for Everybody* 166
2004 *Feministing*: Feminism Goes Online 167
2004 March for Women's Lives 170
2005 Condoleeza Rice: First Black Female Secretary of State 171
2006 Indra Nooyi: First Female CEO of PepsiCo 172
2007 Drew Gilpin Faust: Madame President 173
2008 The Fourth Wave: #Feminism 175
2009 "The Battle of the Sexes Is Over" 176
2009 Equality in the Workplace: The Lilly Ledbetter Fair Pay Act 179
2009 The Big Reversal: Single > Married 180

CHAPTER 10: 2010S
FEMINISM IS TRENDING / 182

2010 Moms at Work: Reasonable Break Time 185
2010 Kathryn Bigelow: First Woman to Win an Oscar for Best Director 186
2013 The Right to Fight: The Pentagon Removes Ban on Women in Combat 189
2015 Love Is Love: Same-Sex Marriage 190
2015 The First Women's Mosque in America 191
2016 Beyoncé's *Lemonade* 193
2016 Hillary Clinton: First Female Presidential Nominee of a Major
Political Party 194
2017 The Women's March 197
2017–2018 Me Too & Time's Up 198
2018 The Pink Wave 201

Afterword Lead the Charge, Ladies! 203
Notes 204
Sources/Suggested Reading 216
Acknowledgments 217
Index 218

WELCOME TO
THE ILLUSTRATED FEMINIST!

———

Ladies, we're here to celebrate! Let's celebrate the one hundredth anniversary of American women being granted the right to vote in 1920. Let's celebrate ten decades of progress in women's rights. Let's celebrate the successful, radical-thinking, home-in-the-kitchen, out-in-the-workforce, up-to-bat, political, artistic, scientific, forward-moving women! Let's celebrate feminism—with strength and style!

We have ten chapters in this book, for ten decades of progress, backslides, backlash, and transformation related to the advancement of women.

Each chapter features ten notable women, events, achievements, or movements in feminism from that decade. You can open the book to any page and discover a pivotal moment from the past century, or visit with a favorite female icon. Or you can read chronologically to get a feel for the vast and sweeping history of American women—how far we've come, and how far we've yet to go. You can immerse yourself in a particular decade, or pick and choose your who, what, when, where, why, and how.

Between these pages live fascinating stories of trailblazing women in business, popular culture, politics, the arts, and sports. You might be surprised to hear about important laws, social movements, and feminist theories. There are some illuminating statistics, too—both positive and negative. And there are suggested readings and notes in the back, for when you're inspired to dive in further.

In so many ways, women have more opportunities and greater equality now than ever before. These achievements, however, have not come easily. Millions of women have fought to change our society's deeply rooted gender biases and inequalities. These women worked hard for success and for justice, amid daunting obstacles and opposition. They are our foremothers—pioneers who are proud to have paved this path for us to tread now.

This book is by no means intended to be a complete and comprehensive history of American feminism in the past century. Rather, it is a curated collection of some key moments and figures, in hopes that it will light a fire under feminists new and old to learn more and bring these lessons into their own lives.

Let's continue this inspiring story . . . and let's celebrate it!

The best way for us to cultivate fearlessness in our daughters and other young women is by example. If they see their mothers and other women in their lives going forward despite fear, they'll know it's possible.

GLORIA STEINEM

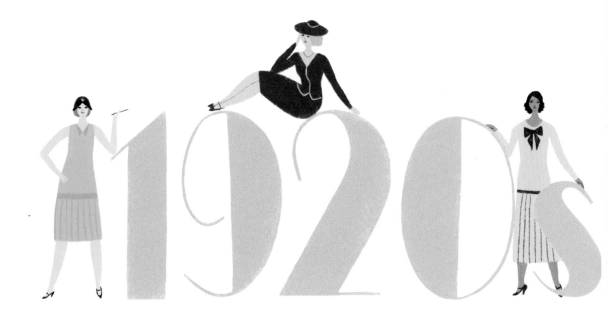

THE ROARING TWENTIES

The Roaring Twenties started with a bang! The Nineteenth Amendment to the Constitution was ratified, and women were granted suffrage: the right to vote. After so many years of protesting and fighting (as part of the first wave of American feminism),[1] women's voices began to be heard.

Change was in the air. It was the Jazz Age, and women were swept up in its energy—in the syncopated rhythms of the music, the bold fashion, and the "scene."

A growing number of women went to work and became involved in public life. Every day, more and more women could be seen driving cars, smoking publicly, and dancing in clubs. For the first time, there was a female governor (see page 23) and a female senator.[2]

Fashion began to reflect these radical changes in women's lives. Clothes were made to be more comfortable, for mobility and activity. No more corsets! Shorter dresses! Bobbed hair! Freedom of expression! Young women reveled in this new-found freedom.

The word of the day was MODERN.

The right of citizens of the United States to vote shall not be denied or abridged by the United States or by any State on account of sex.[3]

THE NINETEENTH AMENDMENT

VOTES FOR WOMEN!

THE NINETEENTH AMENDMENT[4]

They struggled. For decades. Finally, in 1920, women were granted the right to vote.[5] Since the nineteenth century, American suffragists, including Susan B. Anthony (1820–1906) and Alice Paul (1885–1977), had lobbied, marched, protested, picketed, lectured, shouted, and fought to gain this basic civil right.[6] These women are often referred to as the "first wave" of feminists.[7] In 1878, the Nineteenth Amendment was first introduced by Senator Aaron A. Sargent, who befriended Susan B. Anthony on a train ride in 1872. Only forty-one years later, in 1919, did Congress submit it to the states for ratification. It was finally ratified on August 18, 1920.[8] Why then? During World War I, many women joined the war effort. In September 1918, at the end of the war, President Woodrow Wilson (who previously did not endorse suffrage) addressed the Senate and played on senators' patriotic sentiments in favor of voting rights for women. He famously said, "We have made partners of the women in this war. Shall we admit them only to a partnership of suffering and sacrifice and toil, and not to a partnership of privilege and right?"[9]

WOMEN'S WELFARE AND HEALTH CARE

THE SHEPPARD–TOWNER MATERNITY AND INFANCY ACT

The Sheppard–Towner Maternity and Infancy Act was the first federally funded health-care program and is considered an important milestone in the history of social welfare programs in the United States. It was first introduced by Representative Jeannette Rankin (1880–1973)[10] of Montana in July 1918. Women's groups lobbied for years to pass it, and it became the first major legislation following their enfranchisement. The act provided money for five-year periods and helped to establish three thousand prenatal and child health-care centers, mostly in rural areas. The goal: to reduce high mortality rates among mothers and newborns. Sadly, in 1929, the funding was ended after opposition by the American Medical Association, which saw the act as a socialist threat to its professional autonomy.

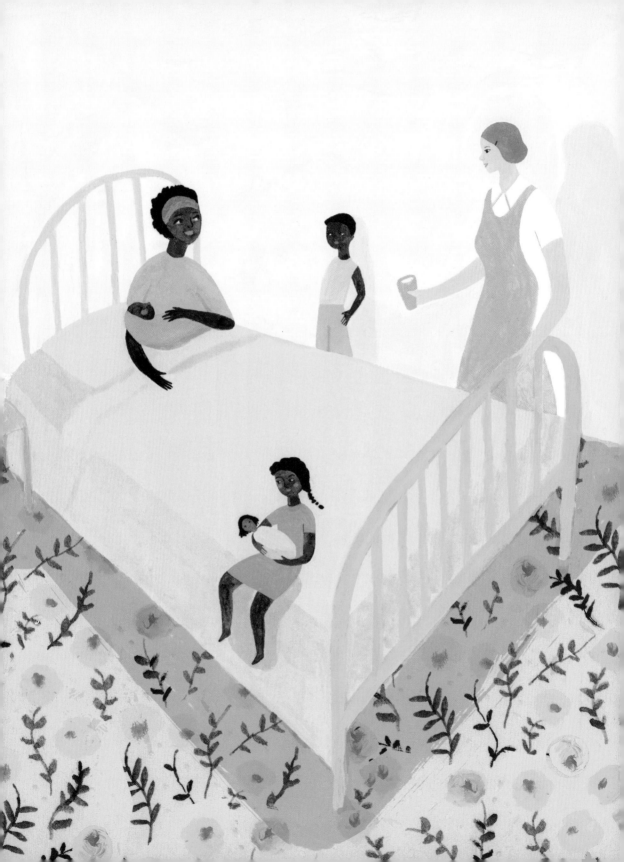

SADIE TANNER MOSSELL ALEXANDER

FIRST AFRICAN AMERICAN WOMAN TO EARN A PH.D.

Sadie Tanner Mossell Alexander (1898–1989) was a woman of many firsts. In 1921, she became the first African American women to earn a Ph.D., in economics, in the United States. She later studied law, becoming the first African American woman to graduate from the University of Pennsylvania Law School, in 1927, and also the first black woman admitted to the Pennsylvania Bar. Alexander distinguished herself as a lawyer, civic activist, and humanitarian, and in 1947 was appointed by President Harry S. Truman to the President's Committee on Civil Rights. This committee ultimately led Truman to call for a federal law outlawing lynching.

> I never looked for anybody to hold the door open for me. I knew well that the only way I could get that door open was to knock it down; because I knocked all of them down.

SADIE TANNER MOSSELL ALEXANDER

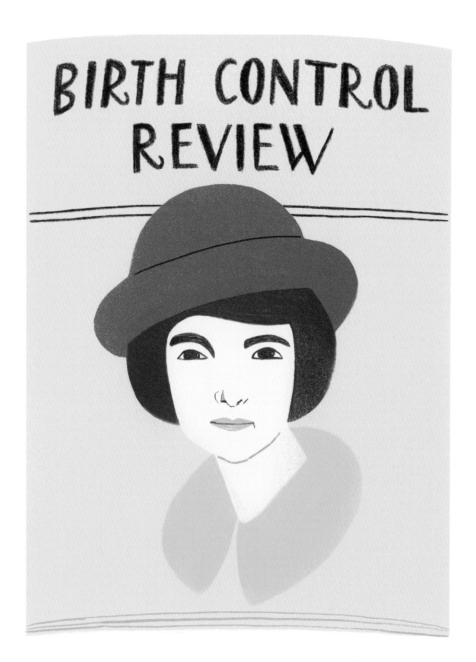

No woman can call herself free who does not own and control her body.

MARGARET SANGER

★ 1921 ★

MARGARET SANGER

AND THE AMERICAN BIRTH CONTROL LEAGUE

In 1921, Margaret Sanger (1879–1966) established the American Birth Control League (ABCL) at the First American Birth Control Conference in New York City. Sanger[11] was a prominent sex educator, a writer, and an obstetrical nurse. In 1916, she opened the first birth control clinic ever in the United States, in Brooklyn, and was arrested for it. The ABCL opened its first legal clinic in 1923, where it conducted research on contraception methods and addressed concerns from women, doctors, and other clinics throughout the country. The ABCL had several goals: to encourage women to control their own fertility, to educate them about "the dangers of uncontrolled procreation,"[12] to fight for legislative support, and to promote the founding of birth control clinics. It organized many conferences and also published a monthly journal,[13] all in an effort to disseminate accurate information about contraceptives. In 1942, the ABCL became the Planned Parenthood Federation of America, which celebrated its hundredth anniversary in October 2016.

★ 1921 ★

KOTEX
THE FIRST COMMERCIALLY AVAILABLE DISPOSABLE SANITARY NAPKIN

—

Before 1921, women would walk around wearing a variety of contraptions during menstruation. Sometimes they simply used cloths or other absorbent materials, like rabbit skins, and wore dark clothing during their periods. No one really spoke about it; anything to do with menstruation, pregnancy, or childbirth was deemed inappropriate and improper to discuss. Then, in 1921, the first successful[14] disposable sanitary napkin came on the market. It was inspired by—wait for it—the highly absorbent disposable bandages that were made of wood pulp and were used to dress wounds in military hospitals. Initially, disposable pads were too expensive for many women. When they were finally made affordable, a method arose in drug stores to allow women to shop for pads with some discretion. Women could place money in a box and take a package of Kotex pads from the shop counter themselves, so that they would not have to speak to the clerk. Additionally, the sanitary napkin packaging was elegant and minimally labeled, to further save the shopper from any embarrassment.[15]

THE FLAPPERS

THE PARTY WOMEN OF THE JAZZ AGE

—

In 1922, a small magazine called *The Flapper*[16] published its first issue, proudly introducing the eponymous woman[17] as one who breaks with traditional values to embrace freedom and modernity. The fashionable flapper had short, sleek hair, exposed her limbs, wore makeup, drank in public, and danced all night in jazz clubs. This way of life was in sharp contrast with the confining Victorian fashions and more passive manners of previous generations of women. The flapper's newfound freedom to breathe and walk without a corset encouraged women to leave the house and become more active. Although it was a trend that empowered myriads of young women, many found them outrageous, immoral, and downright threatening to conventional society. Ultimately, flappers are considered by many to be the first generation of independent women in America—women who pushed social, political, and sexual barriers.

FLORENCE SABIN
FIRST LADY OF AMERICAN SCIENCE

—

In 1925, Florence Sabin (1871–1953) became the first female member of the National Academy of Sciences.[18] She was also the first woman to graduate from Johns Hopkins University Medical School, in 1900, and became its first female full professor in 1917. A pioneering medical researcher, Sabin is best known for her research on brain structure, the lymphatic system, blood cells, and tuberculosis.

I hope my studies may be an
encouragement to other women,
especially to young women,
to devote their lives to the larger
interests of the mind.

FLORENCE SABIN

NELLIE TAYLOE ROSS

FIRST FEMALE GOVERNOR

———

Nellie Tayloe Ross (1876–1977) was a political pioneer. In 1925, only five years after women were granted the right to vote, she became the first woman to serve as governor in the United States. She was elected governor of Wyoming in 1924, after the death of her husband, William Ross, the preceding governor, and served from 1925 to 1927. Running as a candidate was a huge gamble, but Ross was ambitious, and she won. To this day, Ross has been the only female governor of Wyoming! After her term, Ross remained active in Democratic party politics and served as director of the Women's Division of the National Democratic Committee. In 1933, President Franklin D. Roosevelt appointed Ross director of the Mint; she was the first woman to hold this position. Later, she became the first woman to have her face appear on a Mint metal and the first to have her name inscribed on a cornerstone of a government building: the U.S. Bullion Depository in Fort Knox, Kentucky.

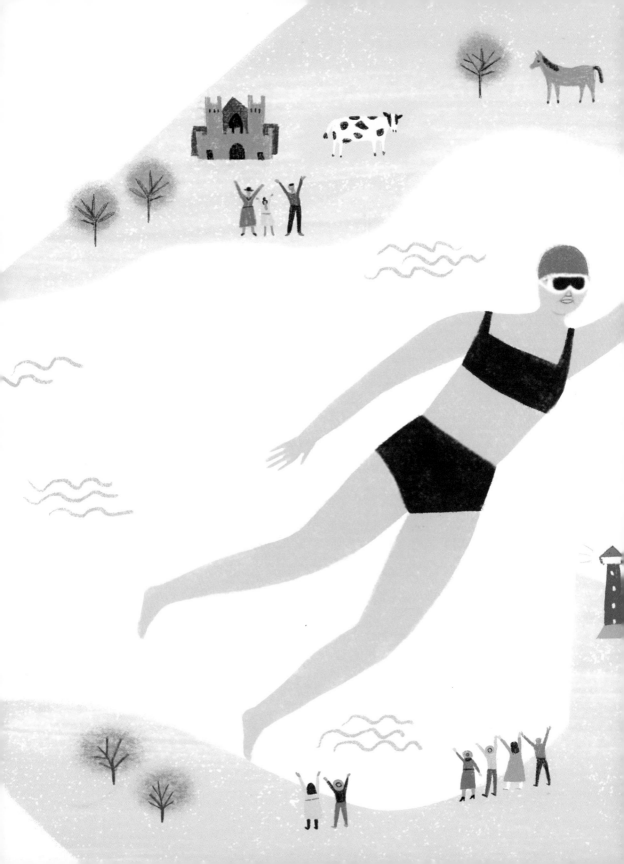

England

France

GERTRUDE CAROLINE EDERLE

QUEEN OF THE WAVES

In 1926, Gertrude Caroline Ederle (1905–2003) made history: she became the first woman to swim across the English Channel. Ederle was an American competition swimmer, an Olympic gold medalist,[19] and a former world record holder. Despite the tricky currents in the Channel, and the many people who doubted her, Ederle swam the thirty-mile stretch from France to England in 14 hours 31 minutes. She broke the men's world record by 1 hour 59 minutes! Her achievement won her fame back in the United States, and she was called "Queen of the Waves." President Coolidge even named her "America's best girl." Unfortunately, Ederle's hearing was irreversibly damaged by the swim; however, her disability inspired her to become a swimming instructor for deaf children. Ederle was inducted into two halls of fame: International Swimming, in 1965, and Women's Sports, in 1980.

★ 1928 ★

CLARA BOW
THE ORIGINAL IT GIRL

Clara Gordon Bow (1905–1965) was an icon of the Roaring Twenties, first famous in silent films and later in "talkies." Nicknamed "the It Girl" for her appearance in the 1927 romantic comedy silent film *It*, Bow made a scandalous appearance in 1928 on the cover of *Vanity Fair*, where she gleefully wears a bathing suit that exposes her shoulders and legs. To many, this cover was utterly scandalous and indecent. Yet other young women happily followed her example: shorter skirts, smaller bathing suits, more bare skin. Bow's bold pose and even bolder garment perfectly encapsulate the audacity and newfound freedom that many women felt in the 1920s.

1930s

PIONEERS

The 1920s are lauded as an age of female enlightenment. Not so for the 1930s.

The most infamous stock-market crash of the twentieth century occurred in 1929, causing a worldwide economic crisis. Known as the Great Depression, the hard times that followed had devastating effects on both rich and poor.

What happened to the feminist fervor of the previous decade during this time of hardship and poverty? Not only did it diminish—it almost completely disappeared. There was simply no time or headspace for these modern ideas. The priority became to survive. The "new women" of the 1920s were gone.

Nevertheless, the 1930s did introduce us to several women pioneers. Amelia Earhart flew solo across the Atlantic (see page 35), and Eleanor Roosevelt was a First Lady way ahead of her time (see page 39).

In terms of women at work, some interesting things were happening: While men's employment rates declined during the Great Depression, women's employment rates actually went up. In many homes, women were the only breadwinners. Their wages—as low as they were—became crucial to the family's livelihood.

Yet a popular phrase at the time was "Don't steal a job from a man." There was pronounced public hostility toward women who worked.[1] With the decrease in support for women's rights, traditional ideals made a comeback. There was a romanticizing of home and family, and women were encouraged to return to their conventional role as housewives.

Thus, even though women were indispensable in the face of a struggling economy in the 1930s, it would take years before their work and contributions would be taken seriously.

WOMEN IN HARD TIMES

THE GREAT DEPRESSION

The big market crash of 1929 began a decade of economic turmoil: the Great Depression. In times of extraordinary stress and hardship, people often turn back to traditional values, pining for more conservative notions, which feel comfortable and safe. The ideas about equality for women, which had blossomed in the previous decade, were halted. Women were encouraged to take care of the home and leave work in order to make jobs available to men. Though the year 1930 marked the tenth anniversary of women's right to vote, many women remained indifferent to their new civic power and did not seek to educate or involve themselves in political issues.

★ 1931 ★

JANE ADDAMS

FIRST AMERICAN WOMAN TO RECEIVE THE NOBEL PEACE PRIZE

Jane Addams (1860–1935) is known as the "mother of social work." In 1889, she founded Hull-House with her friend Ellen G. Starr (1859–1940), which provided multiple social and care services for the immigrant and poor population living in the Chicago area.[2] Addams was also a public philosopher, sociologist, author, and leader in the women's suffrage movement. She was a huge advocate for peace and spoke out against America's involvement in the First World War. In 1915, Addams was appointed both chair of the Women's Peace Party and president of the International Congress of Women at The Hague. She then co-founded the Women's International League for Peace and Freedom in 1919 and served as president until 1929. In 1931, Addams was presented the Nobel Peace Prize for her commitment to peace and public service, the first American woman to be honored with the award.

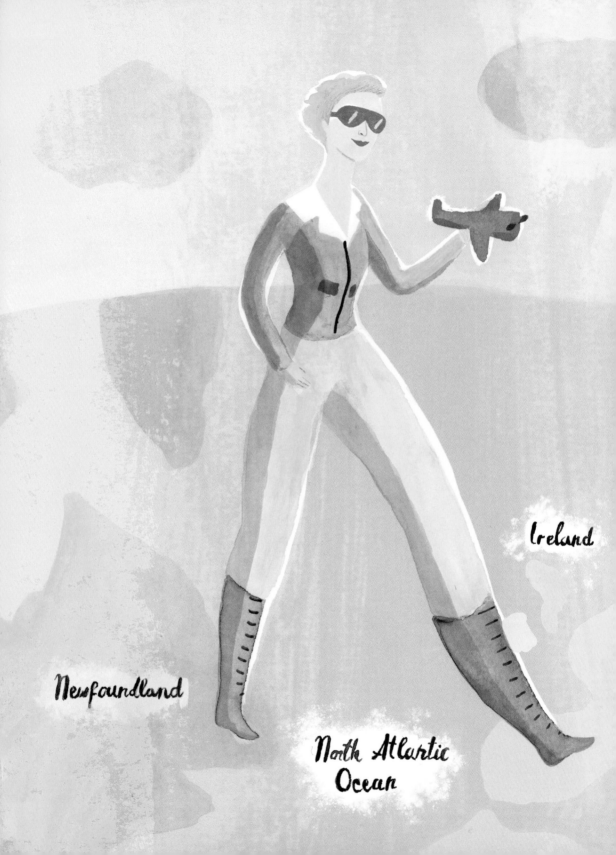

Ireland

Newfoundland

North Atlantic
Ocean

★ 1932 ★

AMELIA EARHART

FIRST LADY OF THE SKY[3]

It's a bird . . . It's a plane . . . It's Amelia! In 1932, Amelia Earhart (1897–c.1939), nicknamed "Lady Lindy" after Charles Lindbergh,[4] became the first woman to fly alone over the Atlantic Ocean. On May 20, Earhart departed from Newfoundland, Canada, and flew to Culmore, Northern Ireland. The impact of this amazing achievement cannot be underestimated; it opened new frontiers of imagination for what was possible for women. She received the Distinguished Flying Cross for her awesome achievement. Earhart was also a member of the National Woman's Party and a supporter of equal rights for women. For example, she lobbied President Hoover for the Lucretia Mott Amendment (ERA) in February 1937.[5] Later that year, while attempting to fly around the globe, she mysteriously disappeared over the Pacific Ocean; she was officially declared dead in early 1939. Earhart is remembered for her bravery and extraordinary triumphs, both in aviation and in women's rights.

> Women must try to do things as men have tried. When they fail, their failure must be but a challenge to others.
>
> AMELIA EARHART

HATTIE WYATT CARAWAY

FIRST WOMAN ELECTED TO THE SENATE

While representing the state of Arkansas in the Senate, Thaddeus Caraway, husband of Hattie Wyatt Caraway (1878–1950), suddenly died mid-term. Back then, it was customary for a widow to take her husband's place, so Hattie did just that. When her term was over, in May 1932, Caraway shocked Arkansas politicians by announcing that she would run for a full term in the upcoming election. Caraway told reporters, "The time has passed when a woman should be placed in a position and kept there only while someone else is being groomed for the job."[6] Once elected, Caraway became the first woman to chair a Senate committee and the first woman to preside over the Senate. She served a total of fourteen years in the body. In 1996, the Senate included her portrait in its collection.

Do what you feel in your
heart to be right.

ELEANOR ROOSEVELT

ELEANOR ROOSEVELT

A NEW KIND OF FIRST LADY

In 1933, Eleanor Roosevelt (1884–1962) became First Lady, a position she held for longer than any other First Lady (twelve years, thanks to her husband, Franklin D. Roosevelt, spending an unprecedented four terms in office).[7] More important, she dramatically redefined the role, setting an example for First Ladies to come. Not content to sit on the sidelines or merely host dinners, Roosevelt was active and influential in American politics, the media, and the public eye. Roosevelt, called the "most liberated woman of the century,"[8] worked avidly for human rights, children's causes, and women's issues. For example, she let only women reporters gain access to her press conferences! By doing so, she supported working women and encouraged major publications to employ women. An independent spirit, Roosevelt had her own daily syndicated newspaper column for twenty-seven years called "My Day," in which she reflected upon her life. She often went on extensive nationwide and international tours for political and social causes. She once even went flying with Amelia Earhart! Though some found Roosevelt's outspokenly progressive ideals distasteful during her lifetime, today she is universally regarded as a groundbreaking leader for women's and civil rights.

★ 1934 ★

LETTIE PATE WHITEHEAD EVANS
FIRST FEMALE BOARD MEMBER OF A MAJOR CORPORATION

Lettie Pate Whitehead Evans (1872–1953) was an American business-woman and philanthropist. In 1934, she became the first woman to serve on the board of directors of a major U.S. corporation—specifically, Coca-Cola. How did she achieve this? Whitehead Evans married Joseph Brown Whitehead in 1894, and he later got an exclusive contract to bottle Coca-Cola. In 1906, he died unexpectedly from pneumonia. Lettie, who was thirty-four years old with two young sons, immediately took over the family's business and actively managed the bottling operation, which over time grew to overseeing eighty plants! Almost twenty years later, she was appointed to the board of directors, a position she held for nearly two decades.

Whitehead Evans was a dedicated philanthropist and donated to many different organizations during her lifetime. She established the Lettie Pate Evans Foundation and the Lettie Pate Whitehead Foundation, which continue to operate today.[9] In 2015, the Coca-Cola Company dedicated a meeting room in Lettie's name, saying, "The story of her life in the Coca-Cola system is really remarkable, and her influence is still felt today because of the work of her foundations."

THE NATIONAL COUNCIL OF NEGRO WOMEN

The National Council of Negro Women (NCNW) was founded in 1935 by the educator Mary McLeod Bethune (1875–1955), the daughter of formerly enslaved parents, who was known as the "First Lady of the Struggle" for her commitment to improving the lives of black women. Bethune was disheartened by the lack of cooperation between African American women's groups. She urged their leaders to form a united body that would represent the interests of African American women in Washington. They listened: the first meeting of the NCNW had delegates from fourteen organizations! The NCNW is primarily concerned with issues of racial equality, but is unique in that it aims to defeat sexism and promote women's rights.[10] Today, the NCNW is represented by more than thirty-five organizations nationwide, and more than three million women are associated with it. Their mission is to "harness the collective power of women of African descent, so that they may realize their full potential and create a just society that enhances the quality of life for all people."[11]

★ 1936 ★

MARGARET MITCHELL'S
GONE WITH THE WIND

——

The Pulitzer Prize–winning novel *Gone with the Wind*, by Margaret Mitchell (1900–1949), was published in June 1936, after Mitchell spent nearly a decade writing it. Set in the Old South, the lengthy book tells the coming-of-age story of Scarlett O'Hara, a flawed protagonist as well as a paragon of strength and a survivor in the face of adversity. The book became deeply embedded in American popular culture, especially following the 1939 film adaptation featuring Vivien Leigh and Clark Gable, and more than thirty million copies have been printed worldwide.[12] The book has been criticized for its racially problematic portrayal of the South, among other issues. However, as feminist theorist Sheila Rowbotham states, "Mitchell deserves credit . . . for creating an enduring woman-centered fiction that deals in important ways with issues about ambiguous roles of women in modern society."[13]

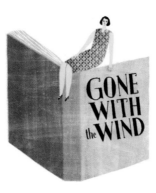

★ 1936 ★

CONTRACEPTION IS LEGALIZED

In December 1936, birth control finally became legal under medical supervision.[14] The court decision *U.S. v. One Package* was the victorious culmination of Margaret Sanger's birth control efforts.[15] According to the United States Second Circuit Court of Appeals, physicians were permitted to prescribe contraceptives when needed to preserve the health and well-being of their patients. Until that time, obscenity laws had prohibited doctors from prescribing birth control to women! This victory encouraged the American Medical Association to finally adopt contraception as a normal medical service. Contraception also became a core component in medical school curricula. However, the medical community did not rush to accept this new responsibility. Women continued to rely on ineffective, and often dangerous, contraceptive advice—such as the recommendation to douche with cleaning products like Lysol—from ill-informed sources until the 1960s.[16]

★ 1939 ★

KAREN HORNEY
AND FEMININE PSYCHOLOGY

In 1939, the psychoanalyst Karen Horney (1885–1952) published *New Ways in Psychoanalysis*. Her book was one of the earliest to challenge accepted Freudian explanations of female psychology, and is one of the seminal texts in understanding women in the twentieth century.[17] Horney, a pioneer of female psychology and the author of *Feminine Psychology*,[18] argued that the origin of many female psychiatric issues is male-centric culture, which produced the biased and androcentric Freudian theory in the first place. Heard of penis envy? Horney rejected such concepts as trivializing and repressing women's emotions. She saw Freudian theories as serving to keep women obedient and infantilized. Horney advocated for an alternative psychological framework, which promoted self-awareness as the cornerstone of becoming a stronger and healthier human being.[19]

WOMEN AT WORK

The first part of this decade has come to be known as "the war years," as America joined World War II in 1941. The war lasted for half the decade, but left its mark on the rest, shaping the culture, politics, and workforce. It notably brought on massive technological advancements, such as the jet engine, nuclear fusion, and rocket technology.

Just as in the 1930s, women were less likely to fight for their rights during the 1940s; war was the more pressing issue. However, America's involvement in World War II marked a huge shift in women's roles. The country needed extra hands to operate the war machine, and women were the answer. Our government initiated a special war-related campaign that led more women than ever before to join the workforce;[1] during World War II, women's employment rates increased by almost 50 percent.[2] Because men were away fighting, women replaced them in all kinds of jobs. In the military, for example, they worked as clerks, gunnery instructors, and other noncombat roles. Previously, women in the armed forces had only been allowed to serve as nurses![3]

Women's fashion was also affected by war. Rationing limited the amount and kinds of materials available. The clothing changed to reflect a more active life-style, becoming more practical and comfortable as women joined the workforce. After the war, the national mood lightened, and people looked for ways to celebrate hope and freedom. Bikinis made their debut,[4] and the baby boom era began.

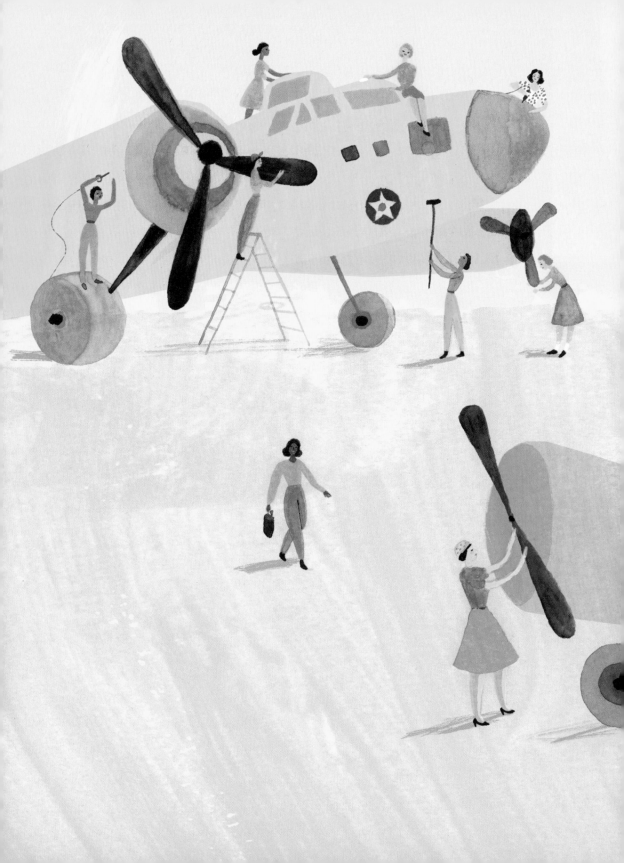

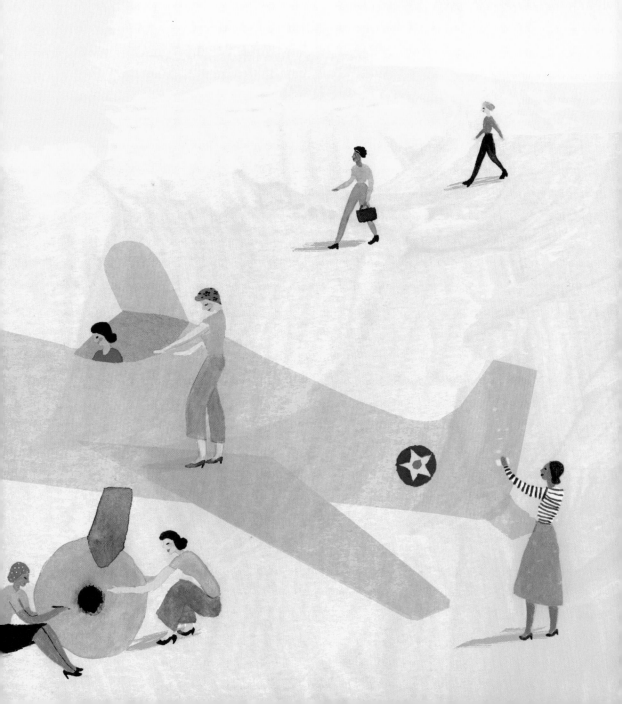

WOMEN AND WORLD WAR II

During World War II, men joined the military in droves, which left large gaps in the labor force. Between 1940 and 1945, more than six million women entered the workforce! Nearly 50 percent of all women were employed at some point during the war years.[5] Women gained access to a variety of positions previously closed to them, like office and professional work.[6] The greatest increase in female workers was in manufacturing: more than 2.5 million women joined factories during the war, representing more than one-third of the industry's total workforce.[7]

It is important to note that though women of color made meaningful gains in the labor force as a result of the wartime labor shortage, these advances were sharply limited by racial segregation and widespread racism.

★ 1941 ★

THE "COMPUTERS"
OF LANGLEY MEMORIAL AERONAUTICAL LABORATORY

The war necessitated a push for aeronautical advancement, leading to a high demand for mathematicians. Enter women "computers," who were brought into the Langley Memorial Aeronautical Laboratory in 1935 to do mathematical calculations by hand, before digital computing was available, in order to free up the (all white male) engineers for "more important" work. The female mathematicians at Langley were extremely successful but went largely unnoticed by the public. Even more unnoticed were the African American computers, who were not hired at Langley until the 1940s, after President Roosevelt issued an order to prevent racial discrimination in war-related work in response to a 1941 protest in Washington, D.C. These women (called the "West Computers," because they were originally segregated in Langley's west wing) greatly contributed to the development of wartime aircrafts, making them faster and safer, and to the space race during the Cold War. The book *Hidden Figures*, which was adapted into an award-winning film, details the lives and achievements of these pioneering and often overlooked women.[8]

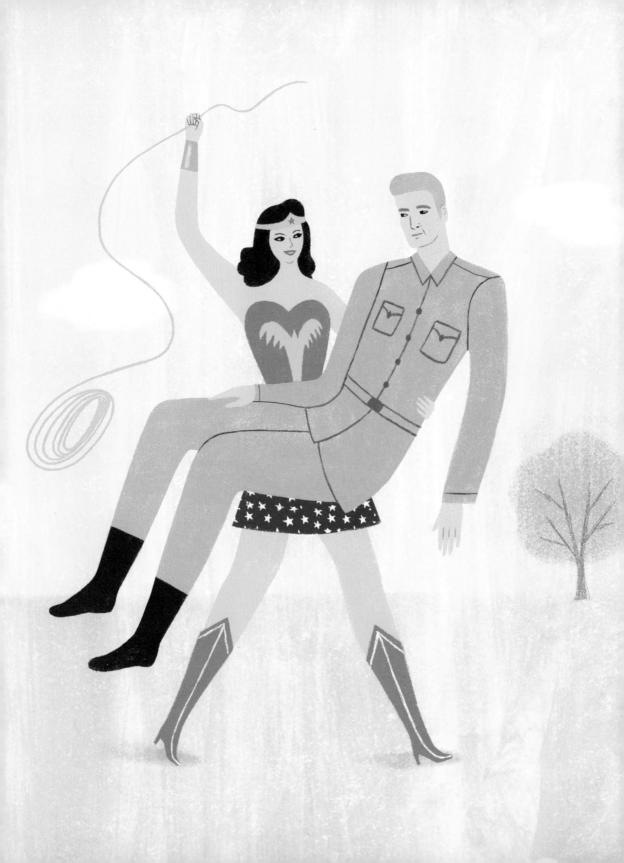

WONDER WOMAN
GODDESS OF LOVE AND WAR

A superhero. A goddess. A feminist icon. Introduced by All-American Comics[9] during World War II, "Wonder Woman is the most popular female comic-book superhero of all time" and one of the longest lasting, according to historian Jill Lepore.[10] Her powers include superhuman strength and speed, and she wears bulletproof bracelets and uses an awesome Golden Lasso of Truth. Wonder Woman fights evil while spreading a message of peace and love to the world.

Wonder Woman has an interesting origin story. She was the brainchild of psychologist and writer William Moulton Marston.[11] Inspired by the burgeoning feminism of his time, particularly by the writings of Margaret Sanger[12] (see page 19), Marston set out to create a powerful heroine who embodied feminist ideals.

Frankly, Wonder Woman
is psychological propaganda for
the new type of woman who,
I believe, should rule the world.

WILLIAM MOULTON MARSTON

★ 1942 ★

ROSIE THE RIVETER

"WE CAN DO IT!"

We all know Rosie the Riveter as a symbol of female empowerment. But who is she, and what is her story?[13] Rosie originated as a cultural icon during World War II. The character Rosie the Riveter was first mentioned in a 1942 song of the same name written by Redd Evans and John Jacob Loeb. The song was recorded by numerous artists and became a national hit. It depicted Rosie as an energetic assembly-line worker, cheerfully contributing to the American war effort: "She's making history, working for victory . . ." The well-known image of Rosie with a raised fist was created in 1942 by Pittsburgh artist J. Howard Miller and was featured on a poster for the Westinghouse Electric Corporation under the headline "We Can Do It!" The poster was meant to boost the female workers' morale during the war. Rosie was also the star of a government campaign aimed at recruiting female workers for national defense industries.[14] The poster was resurrected by feminists in the 1980s, and Rosie became one of the most iconic images of working women. To this day she is used as a symbol of American feminism and women's economic empowerment.

★ 1942 ★

WOMEN IN THE MILITARY

WAC, WAVES, SPARS, WR, AND WASP

In 1942, Congress established women's branches in each of the armed services: the Women's Army Corps (WAAC/WAC),[15] the navy's Women Accepted for Volunteer Emergency Service (WAVES), the Coast Guard Women's Reserve (SPARS),[16] the Marine Corps Women's Reserve (WR), and the Women Airforce Service Pilots (WASP). To attract women to these military roles, the Office of War Information created special propaganda posters and films to target middle-class women who had never before considered joining the workforce. They glamorized the roles of working women, reassuring them that they could maintain their femininity while fulfilling their patriotic duties and would not become masculine due to their service. Approximately 350,000 women joined the military,[17] replacing men in many non-combat jobs, like driving trucks, engineering, and doing clerical work. They also trained new pilots, flew transport planes, repaired equipment, and worked as gunnery instructors. Out of these, 6,520 black women served in the WAAC/WAC, but in segregated units. They were dubbed the "ten percenters" as there was a 10 percent quota for black women. Of the eighty thousand WAVES, only seventy-two were black, as they had initially been barred completely (however, once black women joined, they were integrated with white women). Only a few enlisted in the SPARS. It is important to note that only unmarried and childless women were allowed to join the military, and lesbian women were kicked out if discovered.

ANNIE GAYTON FOX

FIRST WOMAN TO RECEIVE THE PURPLE HEART

In 1941, Lt. Annie Gayton Fox (1893–1987) was assigned to be the chief nurse on duty at Hickman Field, Hawaii. She had been there for less than a month when Japan bombed Pearl Harbor on December 7. Luckily, she was not injured during the attack, and she quickly mobilized to help the wounded. Fox was awarded the Purple Heart on October 26, 1942, for her "fine example of calmness, courage, and leadership [that] was of great benefit to the morale of all with whom she came in contact."[18] In late 1942, the criteria for the Purple Heart changed to those wounded or killed in battle. As a result, in 1944, Fox was issued a Bronze Star in lieu of her Purple Heart. However, the U.S. Armed Forces still recognizes Lt. Annie G. Fox as the first woman to ever have been awarded the Purple Heart.

A LEAGUE OF THEIR OWN

THE AAGPBL

It was World War II, and Chicago Cubs owner and chewing gum magnate Philip Wrigley was worried—but not for the reasons you might think. He was worried that baseball would disappear, since so many of the nation's young men were away at war. To keep the game alive, Wrigley created the All-American Girls Professional Baseball League (AAGPBL).[19] The league existed from 1943 to 1954 and attracted nearly six hundred female athletes. In 1948, the league had its peak attendance at more than nine hundred thousand spectators. The teams included the Kenosha Comets, the Racine Belles, and the Milwaukee Chicks, and the most successful team, the Rockford Peaches, won four championships. The athletes had to be not only skilled but also ladylike—for Wrigley and the other founders of the league, femininity was a high priority. After the team-mates' daily practice games during spring training, they were required to attend Helena Rubinstein's evening charm-school and beauty classes, in order to maintain a physically attractive appearance.[20] A reunion of players held in 1986 revived interest in the league and inspired the classic 1992 film *A League of Their Own*, directed by Penny Marshall and starring Geena Davis and Tom Hanks.

Your fans want you to look
and act like ladies and still
play ball like gentlemen!

DON BLACK, PRESIDENT OF THE RACINE BELLES[21]

★ 1944 ★

SEVENTEEN MAGAZINE

Seventeen, the quintessential magazine for teenage girls, was first published in 1944. At the time, teenagers were a modern cultural concept. In the past, children had simply turned into adults, but now adolescents were a new demographic group. *Seventeen* recognized the rising power of teenagers and the emerging youth culture[22] and created a magazine especially for girls aged thirteen to nineteen. One of the original goals was to provide teenage girls with role models of working women and to introduce them to different career paths. The magazine also discussed fashion, leisure activities, politics, and social issues relevant to teens. It included fiction writing, as well; writer and poet Sylvia Plath had a story published there in 1950. Like many women's magazines of the day, it was not diverse; it wasn't until 1971 that a black model was featured on the cover of *Seventeen*.

Seventeen is your magazine, High School Girls
of America–all yours! . . . You're going to have
to run this show–so the sooner you start thinking
about it, the better. In a world that is changing
as quickly and profoundly as ours is, we hope to
provide a clearing house for your ideas.[23]

HELEN VALENTINE, FIRST EDITOR IN CHIEF OF *SEVENTEEN*, 1944

★ 1947 ★

LUNDBERG & FARNHAM'S
MODERN WOMAN: THE LOST SEX

Despite the huge accomplishments of the feminist movement, there were people who didn't subscribe to the movement's ideas. In 1947, Ferdinand Lundberg, a journalist and social critic, and Dr. Marynia F. Farnham, a psychiatrist, published their bestselling book *Modern Woman: The Lost Sex*. The book was in many ways a repudiation of the changing face of the labor force during World War II, when so many women went to work. According to the authors, feminism was a failed ideology. They viewed it as promoting the hatred of men and falsely encouraging women to find well-being through the route of stereotypical male achievement like employment. They claimed that modern women were discontent because they tried to compete with men. The authors attributed many other social ills to feminism, and called for women to reassume their roles as homemakers in order to reinstate traditional social structures, stability, and happiness and clear the workforce for returning soldiers. The book was extremely popular[24] and set the stage for the social conservatism of the 1950s.

ALICE MARIE COACHMAN
FIRST BLACK FEMALE OLYMPIC GOLD MEDALIST

In 1948, Alice Marie Coachman (1923–2014), an American athlete, became the first black woman ever to win an Olympic gold medal. Specializing in the high jump, Coachman leaped 5 feet 6⅛ inches (1.68 meters) on her first try in the high jump finals. She was the only American woman to win a gold medal in the 1948 London Olympics. Coachman was inducted into the United States Olympic Hall of Fame in 2004, and received recognition for paving the way for future African American track stars.

I think I opened the gate for all of them [black female athletes]. Whether they think that or not, they should be grateful to someone in the black race who was able to do these things.

ALICE MARIE COACHMAN

MOMENTUM, BACKLASHES, AND EYELASHES

After the devastation of the Great Depression and two world wars, many Americans wanted to create a peaceful society, as in "the good old days." World War II may have been over, but the paranoia of the Cold War was soon to follow; the fears it stoked encouraged a new age of conservatism and conformity. Capitalist consumer culture was embraced, thanks to the potent cocktail of a postwar economic boom and anti-communist sentiments. Homeownership rates skyrocketed, and a massive suburbanization took place.

Not surprisingly, in these times of conservatism, traditional gender roles were reinforced. We're all familiar with the idealized image of the fifties housewife: slim, well-groomed, with dinner waiting for her husband. Women were expected and encouraged to be wives and mothers, as a form of patriotism and national security. By holding the nuclear family together, they were holding the nation together.[1]

It is important to note that women of color faced particular challenges in the pursuit of the postwar "American dream." In order to support themselves and their families, many of them worked outside the home. Popular portrayals of femininity and domesticity ignored the lives of minority women. The 1950s were extremely whitewashed in popular culture, and the "happy housewife" was almost exclusively portrayed by middle-class white women.

Yet, in spite of society's pressuring women to stay home, many women were dissatisfied with their domestic roles and chose to remain in the workforce even after the war was over. Thus, despite the seeming dormancy of feminism during this decade, ideas and norms regarding women's roles continued to shift slowly beneath the surface. These changes paved the way for the next decade's sexual revolution and the rebirth of the feminist movement.

THE NEW CULT OF DOMESTICITY

"Cult of domesticity" was a term used by historians to describe the value system during the nineteenth century among middle- and upper-class women. According to this idea, a woman was expected to inhabit the private sphere of the home, run the household, prepare the food, rear the children, and take care of her husband. "True women" were supposed to possess four virtues: piety, purity, domesticity, and submissiveness.

Following World War II, the cult of domesticity had a renaissance, and feminist ideas were largely subdued. Women, who in previous decades had joined the workforce in record numbers, were expected to make way for men returning from war. They were encouraged to become full-time homemakers and take care of the family. From popular culture and media to governmental campaigns, the ideal woman was portrayed as a doting housewife who was content in the domestic sphere. However, women quietly resisted. They still made up about one-third of the labor force, and as more women became independent, premarital sex was on the rise. These shifting social norms ultimately resulted in the second-wave feminism of the 1960s.

★ 1950 ★

THE HAZEL SCOTT SHOW

Hazel Scott (1920–1981) was a jazz musician extraordinaire. Born in Trinidad, she moved to New York City at the age of four. As a child, Scott was a musical prodigy, and she grew up to become a dynamic and bold performer. She performed on many radio and television programs, in nightclubs, on Broadway, and even in films. Scott was also a pioneer: on July 3, 1950, she became the first black person to host her own TV show, *The Hazel Scott Show*, which showcased her range as a performer and musician.[2] Throughout her career, Scott, along with her husband at the time, Adam Clayton Powell Jr.,[3] leveraged her fame in support of the fight for racial equality and civil rights. For example, she refused to perform in front of segregated audiences, and only took on film roles that depicted strong black women.

CHRISTINE JORGENSEN

AND TRANSGENDER ADVOCACY

———

EX-GI BECOMES BLONDE BEAUTY was the front-page headline in the New York *Daily News* when Christine Jorgensen (1926–1989) returned from Europe as a transgender woman. Born George William Jorgensen Jr., she was the first person to become famous in the U.S. for having gender-reassignment surgery. As a teenager, Jorgensen became convinced she was trapped in the wrong body. In 1945, she was drafted into the army. In 1951, after her military service, she underwent a series of sex change operations in Denmark, which were not available legally in the States. When Jorgensen returned to America in 1952, she became an instant celebrity and used her fame to advocate for transgender people. Hollywood loved her and offered her theater and film contracts. She recorded a number of songs and worked as an entertainer, actress, and nightclub singer. The year she died, Jorgensen said she gave the sexual revolution "a good swift kick in the pants."[4]

★ 1953 ★

PLAYBOY MAGAZINE

SEXY OR SEXIST?

In 1953, the first *Playboy* magazine was published by Hugh Hefner out of his kitchen in Chicago. *Playboy*, as controversial as it is, played an instrumental role in shifting the cultural perspective on sexuality. The magazine broke traditional moral codes surrounding sex and nudity, and Hefner himself saw it as an ideological attack on the Puritan ethic of repressed sexuality in American culture. It can also be argued that *Playboy* paved the way for women to embrace and enjoy their own sexuality. As Hefner said, "The feminists who criticize us don't realize how *Playboy* . . . is responsible for the nongirdle look, the bikini, the miniskirt, the openness to nudity."[5] *Playboy* easily attracted criticism from second- and third-wave feminists, who said that the "playboy philosophy" was derogatory toward women, overemphasized women's physicality, and promoted notions of submissiveness and gender inequality.[6] The magazine and Hefner remain topics of debate among feminists to this day.

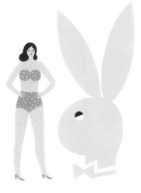

I would like to be known as a person who is concerned about freedom and equality and justice and prosperity for all people.[7]

ROSA PARKS

★ 1955 ★

ROSA PARKS
FIRST LADY OF CIVIL RIGHTS

———

Rosa Parks (1913–2005) was fed up. On December 1, 1955, Parks was riding a Montgomery, Alabama, bus home after a long day, deeply saddened by recent racist violence,[8] tired of the way people of color were treated. So when the bus driver asked her to relinquish her seat in the "colored section" to a white passenger, Parks, a respected civil rights activist, said no. As a result, she was arrested for "refusing to obey orders of bus driver."[9] Her act of defiance sparked the Montgomery bus boycott, led by Martin Luther King Jr., which ignited the civil rights movement. Parks was not the first person to resist bus segregation,[10] but her arrest provided the National Association for the Advancement of Colored People (NAACP) with an excuse to begin the boycott.[11] They were successful in their fight: in late 1956, the Supreme Court ruled that Montgomery's segregated buses were unconstitutional. Parks was the recipient of numerous awards, including the Presidential Medal of Freedom in 1996 and the Congressional Gold Medal in 1999. For her actions, Congress called her the "first lady of civil rights" and the "mother of the freedom movement." When Rosa Parks died in 2005, she was the first woman (and second African American) to lie in honor in the Rotunda of the Capitol.[12]

DORIS DAY
THE GIRL NEXT DOOR

The 1950s are notorious for their images of the perfect housewife, the sparkling kitchen, and heteronormative gender roles. Doris Day (1922–2019), a hugely popular singer and actress, embodied these conservative stereotypes on-screen. She represented the all-around "peaches-and-cream girl-next-door."[13] From the 1940s until the 1960s, Day was the number one box-office star.[14] She starred in thirty-nine films and in the sitcom *The Doris Day Show* (1968–73). Day has been criticized by feminist theorists for portraying a one-dimensional female persona, and her films have also been denounced as "whitewashed cinema."[15] In the 1970s, with the rise of second-wave feminism, Day's conservative-woman persona was no longer in demand in Hollywood, and her career was never the same. More recently, Day's career has been reappraised, and many now view her as an early feminist, interpreting her working-women roles as challenging "the limited destiny of women to marry, live happily ever after and never be heard from again."[16]

★ 1955 ★

THE DAUGHTERS OF BILITIS
FIRST LESBIAN CIVIL AND POLITICAL RIGHTS ORGANIZATION

The Daughters of Bilitis (DOB) was formed in San Francisco in 1955 as a secret social club where lesbians could meet and share their experiences.[17] The DOB later developed into a more politically oriented organization, with a mission to support and educate lesbian women. They released a newsletter titled *The Ladder*, the first nationally distributed lesbian magazine in the United States. It had to be delivered in brown paper bags to avoid being noticed by the Post Office![18]

The DOB came together at a time when prejudice and discrimination against the LGBTQAI community was at one of its highest points. Post–World War II, the State Department declared homosexuals to be a security risk because of their vulnerability to blackmail as well as what the government felt were questionable morals. As a result, many government employees suspected of being homosexual were fired. Cross-dressing became illegal, and the police regularly raided gay bars. Forming the DOB was a brave act against the government.

Like many organizations, the DOB encountered conflict over how best to achieve its mission: Should the group align itself with male-dominated gay rights groups, such the Mattachine Society?[19] Or should it identify with lesbian separatist feminists? The divisiveness of this central question ultimately led to the DOB's end in the 1970s.[20]

★ 1956 ★

LA LECHE LEAGUE INTERNATIONAL
BREAST IS BEST

In 1956, most American women fed their babies with formula. It was considered healthier than breast milk. In fact, the medical establishment did not support breast-feeding and often administered pills to dry up new mothers' breastmilk in the hospital. The LLLI began when two mothers from Illinois, Mary White and Marian Tompson, were breast-feeding their children at a church picnic and many other women expressed interest. As a result, they formed La Leche League International in 1956, along with five other mothers. They realized that there was a need to provide breast-feeding support and information, as women were not getting these from their doctors. Now a global organization, LLLI continues to disseminate knowledge about childbirth and childcare, with the mission to empower women to trust their bodies.

★ 1959 ★

BARBIE
MORE THAN A DOLL[21]

When the first Barbie doll was sold by Mattel in 1959, it was revolu-
tionary: at the time, the market consisted mostly of baby dolls. Women
were expected to be full-time mothers and homemakers, and toys
reflected this. The Barbie doll enabled girls to aspire to other roles
through imagination and role-play. Barbie has appeared, for instance, as
an astronaut,[22] surgeon, Olympic athlete, scientist, rock star, film direc-
tor, rapper, and even U.S. president.[23] More recently, the doll has been
highly criticized for her overt sexuality and unrealistic female body,
making her a controversial role model for young girls.[24] Nevertheless,
Barbie is the most popular doll in history and a cultural icon who has
shaped the imaginations of many generations of girls.[25]

LORRAINE HANSBERRY
"TO BE YOUNG, GIFTED, AND BLACK"

Lorraine Hansberry (1930–1965) was the first African American woman to have a play produced on Broadway. *A Raisin in the Sun*, which realistically portrays a working-class black family and their struggles, was a smash hit when it debuted in 1959, and in 1961 it was adapted into a film. The success of the play helped set the stage for other black writers, actors, and producers. Hansberry was the first black playwright and the youngest American to win a New York Drama Critics' Circle Award, for *A Raisin in the Sun*. During the early 1950s, Hansberry worked as a writer and editor for the black newspaper *Freedom*, and in 1963, she became a civil rights activist. In 1957, she joined the Daughters of Bilitis, one of the first lesbian alliances (see page 81). She often wrote letters about feminism and homophobia for their magazine, *The Ladder*. To conceal her identity, she wrote to the magazine under her initials, L.H.

After her death at age thirty-four from cancer, her former husband, the songwriter Robert Nemiroff, adapted a collection of Hansberry's writings and interviews in a play titled *To Be Young, Gifted and Black*, which ran off-Broadway. It was later published as an autobiography. The title came from a speech given by Hansberry in 1964 to winners of a United Negro College Fund creative writing competition: "Though it be a thrilling and marvelous thing to be merely young and gifted in such times, it is doubly so, doubly dynamic—to be young, gifted, *and black*."[26]

WE WANT A REVOLUTION!

Drugs, sex, love, and war. "The times they are a-changin' . . . ," Bob Dylan sang in 1964.

Indeed, economic, social, and political upheavals shaped this decade like no other in the twentieth century. Counterculture and civil liberty movements abounded as a new generation questioned society's norms.[1] For women, this meant new freedoms. The women's movement took off with a second wave of feminism, aimed at fighting social and cultural inequalities.[2] The Equal Pay Act was passed by Congress (see page 94), as well as Title VII, which prohibited racial and sexual discrimination in the workplace (see page 95).[3] For the first time, a woman became the CEO of a company listed on the New York Stock Exchange.[4]

Free love was in the air, too. The availability of the birth control pill advanced the sexual revolution, which shook up traditional family values and structures. This brought with it the beginning of a shift in society's deep-rooted inequality in gender relations. Enough with sexism! Equality was the key.

<div align="center">

★ 1960 ★

ENOVID

AKA THE PILL

———

</div>

The world's very first oral contraceptive,[5] Enovid, made its debut in 1960.[6] This groundbreaking technology, which took years to develop,[7] had women lining up at their doctors' offices: by 1965, one out of every four married women in America was on the pill.[8] Before Enovid, women were taught that using birth control was a violation of nature, and in many states, it was illegal until 1965![9] Seen as a miracle drug, Enovid was instrumental in the decade's sexual revolution: for the first time, women were able to have sex with a man just for pleasure without the consequences of childbirth. This, in turn, allowed for better family planning and the delay of motherhood, which enabled women to pursue new career paths and be more involved in the workforce.[10] The pill is not all magic, though, and it remains controversial. Its synthetic hormones can be problematic, sometimes causing negative side effects that are not always made clear to users.[11] Regardless, the introduction of the pill was nothing less than revolutionary for enhancing women's lives on all levels.

★ 1961 ★

THE PRESIDENT'S COMMISSION ON THE STATUS OF WOMEN

In 1961, President John F. Kennedy established the President's Commission on the Status of Women, a twenty-member committee chaired by Eleanor Roosevelt. The commission's goal: improving the status of women in America, particularly in areas related to employment and education. The PCSW was also positioned as a Cold War effort to utilize women's untapped talents in the workforce in order to compete against the Soviet Union in the space and arms races. Before closing in 1963, the commission published a report detailing the discrimination faced by women in the workforce. They recommended paid maternity leave, affordable childcare, and equal hiring policies. Although these policies weren't implemented immediately, the report was instrumental in supporting equal employment opportunities for women in future legislation.

⋆ 1962 ⋆

HELEN GURLEY BROWN'S
SEX AND THE SINGLE GIRL

———

Helen Gurley Brown (1922–2012), editor in chief of *Cosmopolitan* magazine for thirty-two years, published her book *Sex and the Single Girl* in 1962. It was a scandalous sensation and sold two million copies in three weeks. Written as an advice book, it covers topics such as career, fashion, love, and entertainment. Most important, it provocatively encourages unmarried women to become financially independent and experience sexual relationships out of wedlock. The book recognized the 1960s' newly prolonged state of singlehood not only as legitimate, but also as a time of life to celebrate.

The only way for a woman, as for a man,
to find herself, to know herself as a
person, is by creative work of her own.

BETTY FRIEDAN

★ 1963 ★

BETTY FRIEDAN'S
THE FEMININE MYSTIQUE

Betty Friedan (1921–2006) was a feminist leader and intellectual. In 1963 she published her bestselling book *The Feminine Mystique*, which in many ways sparked the second-wave feminist movement. The book discusses "the problem that has no name": the deep dissatisfaction that many housewives suffered from at that time, despite having a woman's "dream life" (namely, material comfort, a husband, and children). Friedan called this ideal of the happy housewife the "feminine mystique"— the prevalent social belief that all women can find fulfillment in the domestic sphere alone, with no need for higher education, a career, or a political voice. In the book, Friedan contends that education is a crucial component of the emancipation and happiness of women. She believed that women can—and in many cases, should—have a successful career as well as a family in order to find fulfillment. Though this is a seminal book in feminist history, it has some big issues. Most significant, Friedan discusses only a small section of women in American society—white, middle- and upper-class—and ignores a whole set of working-class and minority women who did not have the luxury of being housewives. These women were arguably the most affected by sexism and inequality but were left out of the book.[12]

★ 1963 ★

THE EQUAL PAY ACT

The Equal Pay Act (EPA) was signed into law on June 10, 1963, by President John F. Kennedy as part of his New Frontier Program. The landmark act, which amended the 1938 Fair Labor Standards Act,[13] mandated equal pay for equal work. The goal: to abolish gender-based wage disparity once and for all. Republican congresswoman Winifred C. Stanley (1909–1996) first advocated for equal pay in 1944, but she wasn't successful. Why? One reason was that postwar, women were discouraged from working and pressured to leave their jobs (see page 71). By the 1950s, two-thirds of American families had a breadwinning husband and a stay-at-home wife. Since women's income was not considered vital to the standard household, wage disparity was not considered a pressing issue. It took almost twenty years and much lobbying to convince the government to pass legislation to address wage disparity. Though the EPA did eventually pass, unequal pay remains an issue for many women today.[14]

★ 1964 ★

THE CIVIL RIGHTS ACT

On July 2, 1964, the Civil Rights Act was signed into law by President Lyndon B. Johnson. Perhaps the most significant section of the act was Title VII, which prohibits labor discrimination on the basis of race, color, religion, sex, or national origin. This meant that it became illegal for employers to deny employment or set different working terms based on an employee's identity; previously, if you were a woman or a person of color, many jobs were simply not open to you. The Civil Rights Act was extremely controversial; it prompted long government debates, protests, and even racial violence from its opponents. Though the Act did not end discrimination, it was a step toward ensuring equality in the workforce. Today, The Civil Rights Act is considered the most important act of its kind since the abolishment of slavery.

It's interesting to note that the word "sex" was actually added to Title VII as an afterthought; According to some, opponents of the Act hoped that the inclusion of gender equality would sound so preposterous as to lead to the Act's dismissal.[15] Luckily, that was not the case.

When I go to the Boston Marathon now,
I have wet shoulders—women fall into
my arms crying. They're weeping for joy
because running has changed their
lives. They feel they can do anything.[16]

KATHRINE SWITZER

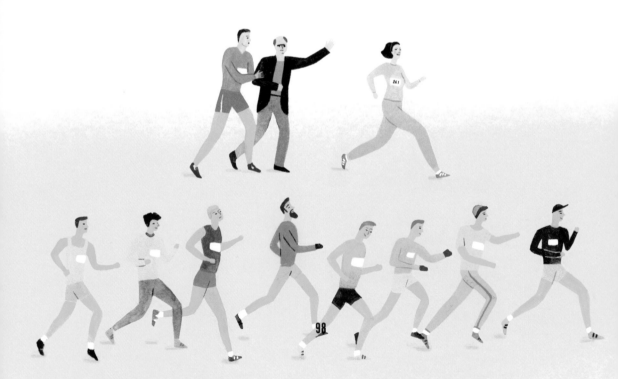

KATHRINE SWITZER

SHE SHOULD RUN

———

In April 1967, Kathrine Switzer (1947–) became a hero of the women's rights movement: she was the first woman to run as a numbered entry in the Boston Marathon, one of the oldest and most prestigious marathons in the country. She had registered as K. V. Switzer, so it was only at mile 5 that she was discovered by an angry official, who physically tried to stop her. Switzer evaded the attack with the help of her boyfriend and made it to the finish line, completing the then all-male race. The photos of this incident were widespread in the media and were quite sensational. However, it was not until 1972 that women were officially permitted to participate in the Boston Marathon. Undeterred by the pace of progress, Switzer continued her long-distance running career, going on to become the women's winner of the 1974 New York City Marathon.

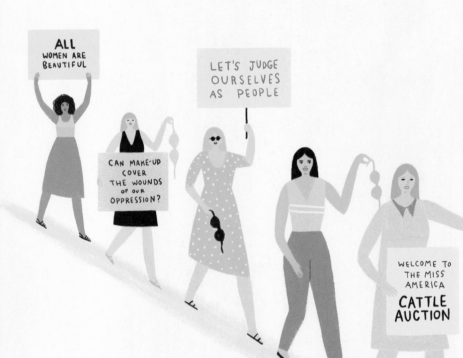

THE FEMINIST PROTEST AT THE MISS AMERICA PAGEANT

"ALL WOMEN ARE BEAUTIFUL!"

Have you ever heard of a sheep being crowned queen? This happened on September 7, 1968, on the boardwalk of Atlantic City, where a feminist demonstration rallied against the Miss America Pageant's degrading treatment of women. The crowning of the sheep was meant to compare the beauty pageant to a "cattle auction." In addition, the protesters tossed female "instruments of torture," such as bras and false eyelashes, into a "freedom trash can." Contrary to popular belief, these objects were never burned, but the term "bra burners" was coined as a result of this event.[17] The protesters also unfurled a large banner that read WOMEN'S LIBERATION. This sensational event drew worldwide media attention to the feminist movement.

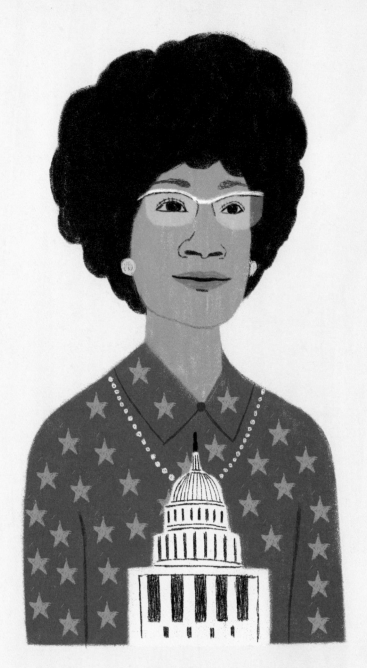

In the end anti-black, anti-female,
and all forms of discrimination are equivalent
to the same thing—anti-humanism.

SHIRLEY CHISHOLM

★ 1968 ★

SHIRLEY CHISHOLM
"UNBOSSED AND UNBOUGHT"

Politician, educator, and author Shirley Chisholm (1924–2005) had a motto: "unbossed and unbought." It reflected her bold and unapologetic championing of women and minorities. In 1968, Chisholm became the first black woman elected to the U.S. Congress, where she represented New York for seven terms, from 1969 to 1983. She made sure that most of her office staff were women and that more than half were black. In 1972, she became the first black candidate for a major party's nomination for president of the United States, and the first woman to run for the Democratic Party's presidential nomination. Not everyone was thrilled[18]—she survived three assassination attempts during her campaign. After leaving Washington, Chisholm said she did not want to be remembered as "the first black woman congressman." In her words, "I'd like them to say that Shirley Chisholm had guts."[19]

★ 1969 ★

THE REDSTOCKINGS

SISTERHOOD IS POWERFUL

A radical feminist group was formed in New York City in early 1969. They called themselves the Redstockings, a play on "Bluestockings," the derogatory term for eighteenth- and nineteenth-century feminists. The color red was swapped for blue to denote revolution and uprising. The Redstockings believed that the existing patriarchal society was exploitative, destructive, and oppressive of women. The "Redstockings Manifesto"[18] called for women to unite in order to achieve liberation. They touted the "pro woman line," which holds that women are never to blame for their oppression; men should be the ones responsible for changing the male-dominated culture.[21] In order to disseminate their ideas, the Redstockings organized "consciousness-raising" sessions, where they spoke about how sexism influences women's lives. They saw it as a method for uncovering the truth and as a means for feminist action.[22]

One of the group's most famous protests was an abortion "speak-out" in New York City in March 1969: At a legislative hearing on possible changes to the law that prohibited abortion,[23] there were about a dozen male speakers and only one woman—and she was a nun. To protest, the Redstockings held their own hearing, where women testified about personal experiences with abortion. This hearing helped shape future discourse on women's reproductive rights. Today, the Redstockings exist as a grassroots think tank focused on women's liberation issues.[24]

THE SECOND WAVE IN FULL SWING

The 1960s caused quite a stir in the feminist arena, and the 1970s were no different. By mid-decade, the women's liberation movement was everywhere. The movement was so pervasive that *Time* bestowed its "Man of the Year" honor in 1975 on "American women."[1] In the seventies, feminists became more organized than before. They were able to effect major social changes and arguably some of the most profound legislative breakthroughs for women, including the landmark 1973 Supreme Court case *Roe v. Wade*, which proclaimed abortion to be a woman's right (see page 115). Future Supreme Court justice Ruth Bader Ginsburg[2] became one of the leading legal authorities on women's rights, cofounding and serving as lead counsel for the Women's Rights Project at the American Civil Liberties Union (ACLU). And for the first time, in 1974, women were able to get their own credit cards without the endorsement of a man (see page 119). Some even found record-breaking success in careers traditionally held by men, like Katharine Graham, who in 1972 became the first female Fortune 500 CEO, at the *Washington Post*. And in 1976, anchorwoman Barbara Walters signed a million-dollar-per-year contract with ABC, making her the highest-paid person, man or woman, in TV journalism at the time.

But this decade had setbacks, too. After a long and heroic fight, the Equal Rights Amendment[3] failed to pass.[4] Women were still not fully equal in the eyes of the law, leaving feminists disheartened. However, compared with previous decades, women's social position—and mindset—had shifted. As Gloria Steinem said in *Time* in 1972, "In terms of real power—economic and political—we are still just beginning. But the consciousness, the awareness—that will never be the same."

THE MARY TYLER MOORE SHOW

"TV'S FIRST TRULY FEMALE-DOMINATED SITCOM"[5]

The Mary Tyler Moore Show broke all the rules of television. A highly acclaimed sitcom, it aired on CBS from 1970 to 1977. Mary Tyler Moore (1936–2017) starred as Mary Richards—a single, independent woman who worked as a TV producer. The show addressed bold feminist topics such as equal pay for women, premarital sex, birth control, and homosexuality. Some feminist leaders at the time felt that *The Mary Tyler Moore Show* didn't go far enough; for example, the theme song uses the term "girl" instead of "woman"—a practice that tends to undermine women's authority—and Mary Richards calls her boss Mr. Grant while everyone else calls him Lou. Nevertheless, the show was one of the first to portray women as realistic and complex characters.[6] *The Mary Tyler Moore Show*[7] empowered women behind the scenes, too: by 1973, twenty-five out of the seventy-five writers on the show were women, which was revolutionary at the time.

★ 1970 ★

WOMEN'S STRIKE FOR EQUALITY

Fifty years after women were granted the right to vote, it was time to shake things up again. Thanks to second-wave feminism, women's rights were back on the agenda—but they needed a publicity boost. Enter the Women's Strike for Equality: a nationwide protest against gender-based oppression, organized by Betty Friedan, feminist leader and author of *The Feminine Mystique* (see page 93). Though initially ridiculed by the media, it was the largest rally for women's rights since the suffragettes, with more than fifty thousand marchers in New York City and throughout the United States. The strike primarily focused on the repeal of antiabortion laws, the establishment of childcare centers, and the promotion of equal opportunities in employment and education. In addition to the march, women symbolically broke coffee cups, threw feminine "objects of oppression" into "freedom trash cans," and held "baby-ins" at offices in order to demonstrate the need for childcare. This rally brought together older and younger generations of feminists. It also gave visibility to the women's movement and sparked further feminist action in the years to come.

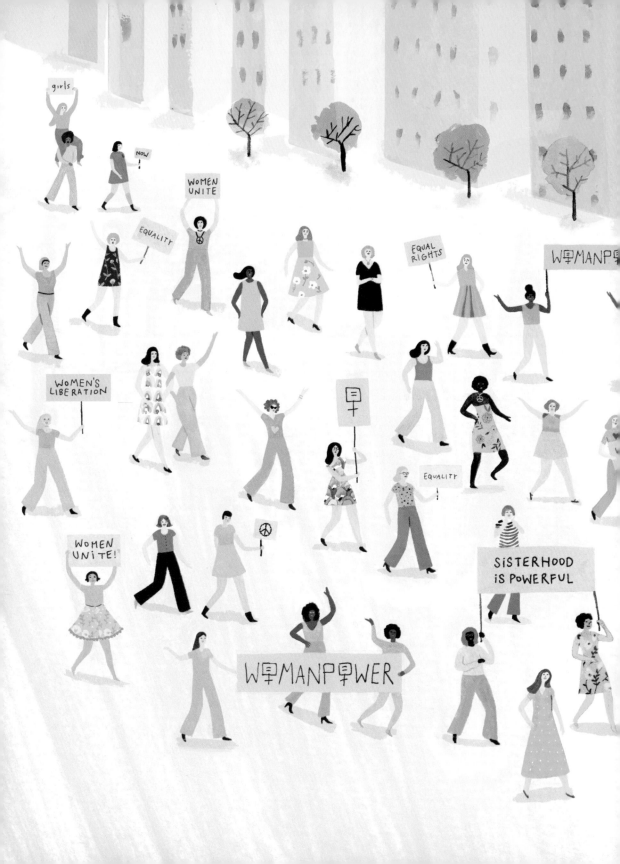

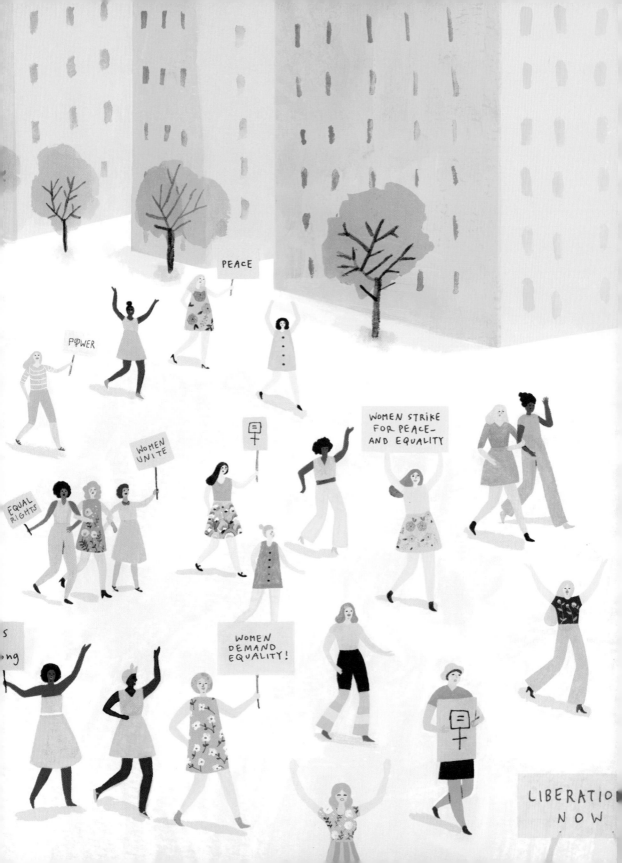

★ 1970 ★

MUJERES DE CORAZÓN
THE COMISIÓN FEMENIL MEXICANA NACIONAL

The Comisión Femenil Mexicana Nacional (CFMN) was established in late 1970 to improve the position of Mexican American women in the workforce and in education. The members didn't identify with white feminists or with the male-dominant Chicano movement; they felt that in order to address all aspects of their intersectional identities they needed to form an independent Chicana (or Xicanisma) organization. One of the biggest issues they took on was coerced sterilization—a pervasive practice that targeted their population. In 1975, in the case of *Madrigal v. Quilligan*, a group of ten women filed a class-action lawsuit against the University of Southern California–Los Angeles County Medical Center for systematically sterilizing Mexican American women without their consent. Although the judge ruled in favor of the doctors, the case led to policies for better-informed consent for patients. Today, the CFMN continues to advocate for the Chicana community.

MS. MAGAZINE

What do Wonder Woman, Beyoncé, and Jackie Kennedy have in common? Yes, they're all amazing, but they also all appeared on the cover of *Ms.* magazine! *Ms.*, a liberal feminist publication that was the first of its kind, was cofounded by second-wave feminist activists Gloria Steinem (1934–) and Dorothy Pitman Hughes (1938–). *Ms.* first appeared in 1971 as an insert in *New York* magazine; the first stand-alone issue was published in July 1972. Steinem explained the motivation for starting *Ms.* magazine: "I realized as a journalist that there really was nothing for women to read that was controlled by women." The founders wanted a publication that would address issues that modern women cared about, not just domestic topics such as fashion and housekeeping. In the years to come, *Ms.* covered topics such as abortion, sexism, and political action. At first, *Ms.* had a lot of opposition from the media. Harry Reasoner, a well-known TV journalist, famously went on air to say that *Ms.* would not last: "I'll give it six months before they run out of things to say." *Ms.* magazine is still published today.

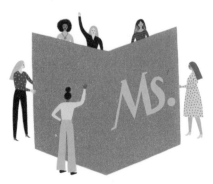

ROE V. WADE

MY BODY, MY CHOICE

———

On January 22, 1973, the Supreme Court case *Roe v. Wade* made history for American women. The plaintiff, Norma McCorvey (1947–2017), couldn't obtain an abortion, which was illegal in her home state of Texas.[8] Represented by Linda Coffee (1942–) and Sarah Weddington (1945–), she filed a case in court, under the alias Jane Roe, against Henry Wade, the district attorney of Dallas County. In a landmark decision, the court ruled 7–2 that abortion[9] is a fundamental right under the Constitution (specifically according to the Fourteenth Amendment, which protects an individual's "zones of privacy," including child rearing, marriage, and contraception).[10] Abortion became legal in all fifty states.

It is hard to overestimate the importance of this ruling. The Supreme Court finally fully recognized the right women have to make decisions over their own bodies. *Roe v. Wade* also lessened the disparity between women of different classes—even when it was illegal, women with means were able to obtain safe abortions, while women who couldn't afford to travel or pay for abortions were effectively forced to have those children or seek out unsafe procedures.

Roe v. Wade remains highly contested to this day[11] and a huge point of partisan debate. Many against it hold the belief that abortion is akin to killing, and that the fetus's right to live surpasses the mother's right to control her own body. However, *Roe v. Wade* is still supported by the majority of Americans,[12] who view it as a basic human right.

BILLIE JEAN KING
AND THE BATTLE OF THE SEXES

In September 1973, Billie Jean King (1943–), a former world number one professional tennis player, won the famous "Battle of the Sexes" tennis match against Bobby Riggs, a former top-ranking tennis player and self-proclaimed male chauvinist. Riggs challenged King in an effort to show that a woman cannot beat a man. King, with thirty-nine Grand Slam titles, felt she "had to win" to prove him wrong. And she did, with the score of 6–4, 6–3, 6–3! At the time, the sensational match set a record for the largest tennis audience and the largest prize awarded. King, the first prominent female athlete to come out as bisexual, is an advocate for gender equality and the rights of women tennis players. She helped form a separate women's tennis tour and was one of the founders—and the first president—of the Women's Tennis Association. In 2006, the U.S. Open stadium was renamed the Billie Jean King National Tennis Center and in 2009, King was awarded the Presidential Medal of Freedom by President Obama.

MONEY OF HER OWN
THE EQUAL CREDIT OPPORTUNITY ACT

If you were a single woman before 1974 and wanted to get a credit card, you were in trouble. Many banks required single, widowed, or divorced women to bring a man to cosign any credit application, regardless of the woman's income. Finally, in 1974, the Equal Credit Opportunity Act (ECOA) was passed, prohibiting financial institutions from discriminating against applicants for credit on the basis of race, color, religion, national origin, sex, marital status, or age. When the government's banking committee outlined the ECOA, it focused on racial and social discrimination. Louisiana congresswoman Lindy Boggs (1916–2013) decided to add the terms "sex" and "marital status" without informing the other members. She photocopied her new version of the bill and distributed it to the committee. According to the House of Representative's Office of the Historian, she then told her colleagues, "Knowing the Members composing this committee as well as I do, I'm sure it was just an oversight that we didn't have 'sex' or 'marital status' included..." The committee unanimously approved the act, and it went into effect on October 28, 1974.

★ 1975 ★

A JURY OF HER PEERS

———

Throughout the twentieth century, American women campaigned to be allowed to serve as jurors. By 1942, only twenty-eight states permitted women to do so, and it was not until 1968 that all fifty states were on board. The reasoning against letting women serve on the jury, in the words of a Florida court in 1961, was that the "woman is still regarded as the center of the home and family life" and that they could not be expected to serve as jurors because they have "to cook the dinners!"[13] Although women were technically allowed to serve on the jury, they had different exemptions than men. Women were allowed to opt out of jury duty and were often discouraged from serving. In Florida, for example, a woman could not serve as a juror unless she previously declared in writing her desire to do so. Only in 1975 did the Supreme Court deem this unconstitutional and end the different jury service policies for women and men.[14]

SARAH CALDWELL

"MUSIC'S WONDER WOMAN"

Sarah Caldwell (1924–2006) was a trailblazing opera conductor and stage director, known for her inventive and cutting-edge productions of challenging operas. Caldwell was a musical prodigy as a child and was later known for her eccentric personality. In 1975, a *Time* magazine cover story called her "Music's Wonder Woman." Shortly afterward, in 1976, Caldwell became the first female conductor at the Metropolitan Opera, with *La Traviata*. In Caldwell's own words, her productions were "not just trying to be different" but "grew out of desperate circumstances." She brought opera to life and made it accessible to a larger audience. For one production she even had a chef cook crepes live on-stage!

> Opera is everything rolled into one . . .
> Once in a while, when everything is
> just right, there is a moment of magic.

SARAH CALDWELL

★ 1978 ★

THE PREGNANCY DISCRIMINATION ACT

———

Before 1978, there were no official laws that protected the rights of pregnant women in the workforce.[15] The Pregnancy Discrimination Act (PDA) of 1978 sought to change that: it amended Title VII of the Civil Rights Act of 1964 (see page 95) to "prohibit sex discrimination on the basis of pregnancy." The PDA was written in response to a Supreme Court decision in *General Electric Company v. Gilbert* (1976). General Electric offered its employees a disability plan but did not cover disabilities related to pregnancy. A group of female employees sued the company for sex discrimination. The Supreme Court argued it wasn't sex discrimination, but Congress disagreed and created the PDA two years later. In 1993, the Family and Medical Leave Act (FMLA) increased employment protections for pregnant women. Today, there is still much to be done to further rights for women in the workplace in regard to pregnancy, maternity leave, and childcare.

POSTFEMINISM

After the turmoil and social upheavals of the 1960s and '70s, America was ready for some stability. The 1980s were a return to conservatism and materialism, led by President Ronald Reagan.[1] There was an emphasis on corporate culture, which brought about the rise of "young urban professionals," aka Yuppies. Popular culture became huge, with widely seen big-budget films (such as *E.T.*, *Back to the Future*, *Ghostbusters*, and *Raiders of the Lost Ark*) and the debut of MTV. In the second half of the decade, the Cold War came to an end.

In previous decades, second-wave feminists disrupted society with their equal-rights laws and breaking of gender boundaries. They were vilified by the hegemony, which painted them as sexless, humorless, angry, and unattractive. As a result, many women in the eighties[2] saw themselves as "postfeminist" and did not want to identify with the feminist movement.[3] In the words of the feminist writer Rebecca Traister, "Feminism was simply frozen. It was a tundra."[4] The ERA once more failed to pass,[5] and the antiabortion movement[6] gained momentum. In 1989, the Supreme Court affirmed the right of states to deny public funding for abortions and to prohibit public hospitals from performing them. In the workplace, sexual harassment was still rampant, as was unequal pay for women.[7] Yet not all was bleak. In 1981, Sandra Day O'Connor (1930–) became the first female Supreme Court associate justice in history. In 1983, Sally Ride became the first woman to go into space (see page 130). In 1986, the Supreme Court finally made sexual harassment at work illegal.[8] There was growing resistance to the unfair treatment of women in films and in art from activist groups like the Guerrilla Girls (see page 137). Women of color made their voices heard: several notable books by black writers were published in the eighties, such as *This Bridge Called My Back: Writings by Radical Women of Color*, edited by Cherríe Moraga and Gloria E. Anzaldúa, and Angela Davis's *Women, Race & Class*, both intersectional looks at feminist issues. All these steps forward kept the feminist flame alive.

Too often, the women were unsung and
sometimes their contributions went unnoticed.
But the achievements, leadership, courage,
strength, and love of the women who built
America was as vital as that of the men whose
names we know so well.

JIMMY CARTER

★ 1980 ★

HERSTORY

NATIONAL WOMEN'S HISTORY WEEK

———

Before there was National Women's History Month, there was National Women's History Week. It was proclaimed by President Jimmy Carter and held March 2–8, 1980. How did it begin? Feminist activists in Northern California were indignant with history books leaving out American women. In 1978, they set out to create a "Women's History Week" in order to celebrate women's cultural achievements and contributions to history. The idea spread across the country, and other communities celebrated their own Women's History Week the following year. In 1980, an alliance of women's groups and historians successfully lobbied for national recognition. Seven years later, Congress declared March of each year to be National Women's History Month.

ALICE WALKER

AND WOMANISM

Author and activist Alice Walker (1944–)[9] coined the term "womanism," as an alternative to feminism, in her 1983 book *In Search of Our Mothers' Gardens*. Walker saw feminism as a limited and white-centric movement. She famously wrote, "Womanist is to feminist as purple is to lavender," meaning that womanism encompasses and expands feminism, in addition to being an alternative. In Walker's words, "Womanism is simply another shade of feminism. It helps give visibility to the experience of black women and other women of color who have always been at the forefront of the feminist movement yet marginalized and rendered invisible in historical texts and the media." Walker also wrote that a womanist is a "woman who loves other women, sexually and/or nonsexually." In her book, Walker uses the metaphor of a garden, where all flowers bloom equally: She hopes that one day the world will be a place where women and men of all races and cultures are equal.

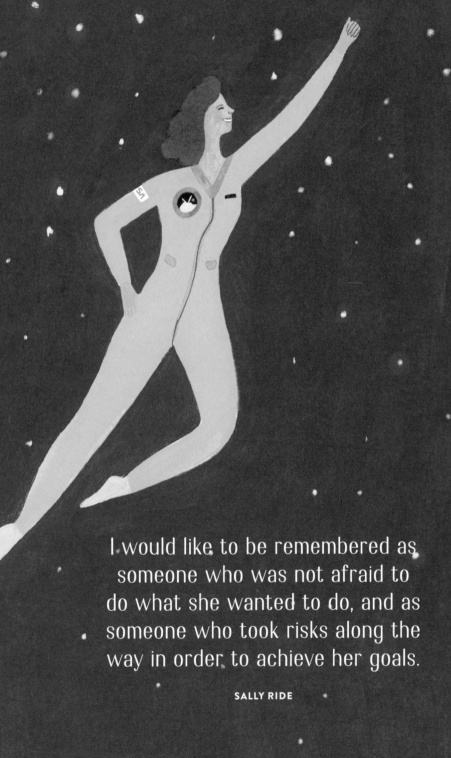

I would like to be remembered as someone who was not afraid to do what she wanted to do, and as someone who took risks along the way in order to achieve her goals.

SALLY RIDE

★ 1983 ★

SALLY RIDE
FIRST WOMAN IN SPACE

In 1983, Dr. Sally Ride (1951–2012) became the first American woman to go to space. She was a mission specialist on the *Challenger* space shuttle. During her history-making flight, Ride worked the robotic arm to help launch satellites into orbit.[10] Ride retired from NASA in 1987 and later became a physics professor at the University of California, San Diego. She cofounded the organization Sally Ride Science in 2001 to encourage women and girls to study science, mathematics, and technology. In 2003, Ride was inducted into the Astronaut Hall of Fame. Ride was also the first acknowledged gay astronaut, though this was revealed only at the time of her death.

MADONNA

QUEEN OF POP

———

Does Madonna even need an introduction? Madonna Louise Ciccone (1958–), the world-famous singer, songwriter, actress, and global pop-culture icon, released her debut album, *Madonna*, in 1983. She is recognized as the bestselling and most influential female recording artist of all time, having sold more than 330 million records worldwide. Madonna revolutionized the world of pop music by making her own persona a work of art. Her style and music have changed over the years, but always remain bold and inventive. Madonna's use of sexual imagery and religious symbolism in her music videos and performances has evoked much public discussion on sexuality and feminism; key examples include "Like a Virgin" (1984), "Papa Don't Preach" (1986), and "Like a Prayer" (1989). Madonna's work is political: she provokes people to think about women's bodies and power in a new way, and believes in freedom of expression without censorship.[11] As author Camille Paglia wrote, "Madonna is the true feminist . . . Madonna has taught young women to be fully female and sexual while still exercising total control over their lives. She shows girls how to be attractive, sensual, energetic, ambitious, aggressive, and funny—all at the same time."[12]

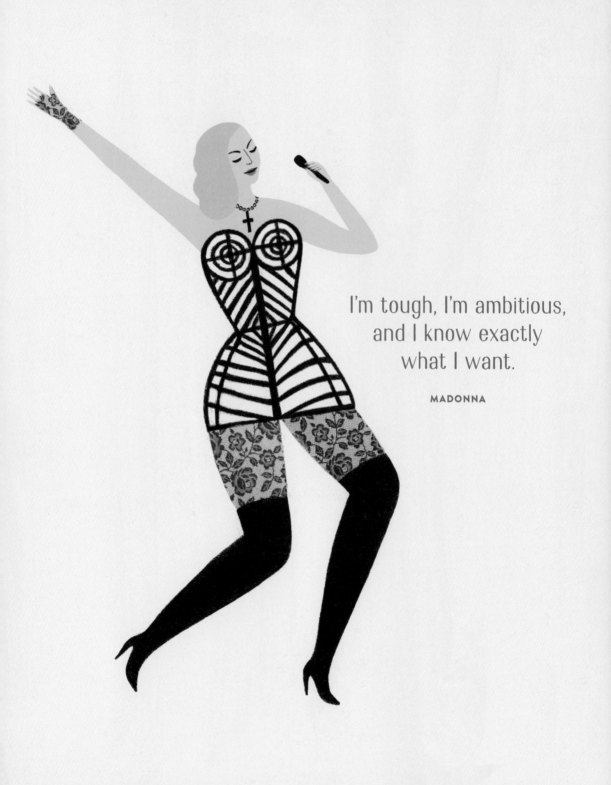

I'm tough, I'm ambitious,
and I know exactly
what I want.

MADONNA

★ 1984 ★

GERALDINE FERRARO
"SOME LEADERS ARE BORN WOMEN"

———

Geraldine Ferraro (1935–2011) was an attorney and a trailblazing politi-
cian. In 1984, while representing New York in Congress, she became the
first woman to be nominated as a vice presidential candidate for a major
American political party. The Democratic nominee, Walter Mondale,
selected Ferraro as his running mate against incumbent Ronald Rea-
gan. This was a huge moment for women in American politics, and many
came out to see her in person, shouting "Ge-rry! Ge-rry!"[13] During her
tenure in Congress, Ferraro pursued a feminist and liberal agenda. She
supported several key pieces of legislation, including the Retirement
Equity Act of 1984, which reformed pension options for women, and
strongly supported abortion rights. Although Mondale and Ferraro lost,
she nevertheless made history.

AUDRE LORDE'S
SISTER OUTSIDER

———

Sister Outsider is a collection of essays and speeches by Audre Lorde (1934–1992), a self-described "black lesbian feminist warrior poet." The book is considered groundbreaking and highly influential in the development of contemporary feminist theories. It addresses many different topics, such as violence against women, love and relationships, police brutality, black feminism, and equal rights. Lorde writes about her personal experiences with sexism, racism, homophobia, classism, and ageism, through which she explores the complex nature of an intersectional identity. The conflict within the title *Sister Outsider* reflects Lorde's idea that her intersectional identity as a black lesbian mother, poet, and partner in a racially mixed relationship provides her with a unique perspective as both a "sister" and an "outsider." She sees this complex identity as one that can be used to spark real change. *Sister Outsider* has become essential reading in academia.

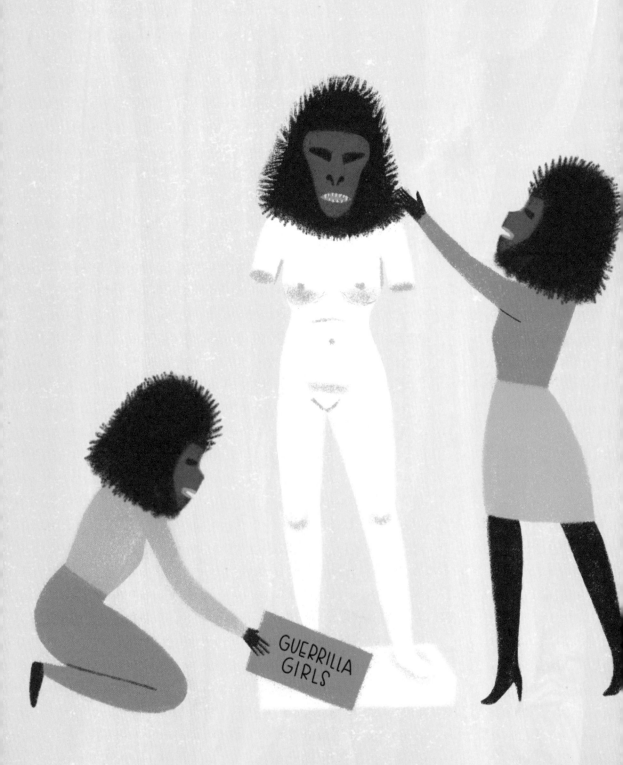

★ 1985 ★

GUERRILLA GIRLS
REINVENTING THE "F" WORD

The Guerrilla Girls is an anonymous group of feminist activist artists with a mission to fight against sexism in the art world. They wear gorilla masks in public to keep the focus on the issues they address; they believe that people won't listen to them if they reveal their identities. As part of their resistance, the Guerrilla Girls make provocative public appearances such as museum takeovers. They use humor and bold visuals to expose gender and racial inequality in art, as well as corruption in politics and popular culture. The group formed in reaction to the Museum of Modern Art's 1985 exhibit "An International Survey of Recent Painting and Sculpture,"[15] which claimed to represent the current landscape in art.[16] Out of 165 artists in the show, only thirteen of them were women. There were only a few artists of color, and all of them were men. Outraged by this blatant inequity, the Guerrilla Girls were born and have been active ever since.

★ 1985 ★

WILMA MANKILLER
FIRST FEMALE CHIEF OF THE CHEROKEE NATION

———

In 1985, Wilma Mankiller (1945–2010) became the first woman to be elected as principal chief of the Cherokee Nation. She served in that role for ten years. Previously, she worked as a social worker and as a community developer. As principal chief, Mankiller doubled employment within the tribe, promoted better education, and revolutionized the health-care system in the Cherokee Nation. Mankiller worked hard to promote Cherokee independence, improve the public image of Native Americans, and fight against the misappropriation of indigenous heritage. After her retirement, Mankiller returned to activism. She authored numerous books, was a tireless advocate for women's rights (she was a close friend of Gloria Steinem) as well as for native people and social justice. In 1998, President Bill Clinton awarded her the Presidential Medal of Freedom.[17]

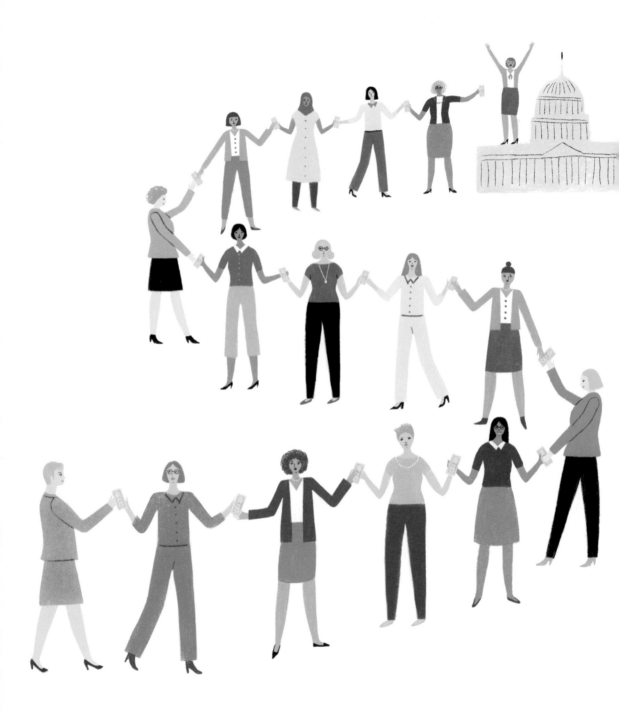

EMILY'S LIST

EARLY MONEY IS LIKE YEAST

———

EMILY's List is a political action committee (PAC) created in 1985 by the political activist Ellen R. Malcolm (1947–). Her mission: to elect pro-choice Democratic women to office. The name stands for "Early Money Is Like Yeast"—it makes the dough rise. It comes from the idea that obtaining large donations in the early stages of a campaign can help attract later donations. Together with twenty-five other women, Malcolm mailed out letters to friends, asking for money, and in 1986 their mission came to fruition: Barbara Mikulski, one of EMILY's List's first two candidates, was elected to the U.S. Senate. Today, EMILY's List goes beyond fund-raising. They not only recruit candidates, but also help with the design and management of their candidates' campaigns. To date, EMILY's List has assisted in electing more than one hundred women to the House, twenty-six to the Senate, sixteen to governors' seats, and more than one thousand to state and local office. EMILY's list is the largest national resource for women—and minority women—in politics.

★ 1989 ★

THE GREAT CROSSOVER

AGE OF MARRIAGE > AGE OF FIRST CHILD

———

Women's demographics shifted significantly in the late eighties: the age of marriage had risen dramatically during the past decade, eventually reaching its record high of almost twenty-four years old. In comparison, the age of women having their first birth had not risen as quickly. In 1989, the two trends crossed each other. Sociologists called this "the Great Crossover."[18] What does this mean? For the first time, many American women were having children before they were getting married. In other words, the Great Crossover marked the moment at which unmarried motherhood became normal for America's large middle class, and signaled that having babies out of wedlock was not as frowned upon as it used to be. The Great Crossover also reflected the relatively new prolonged state of singlehood and the rising independence of women.[19]

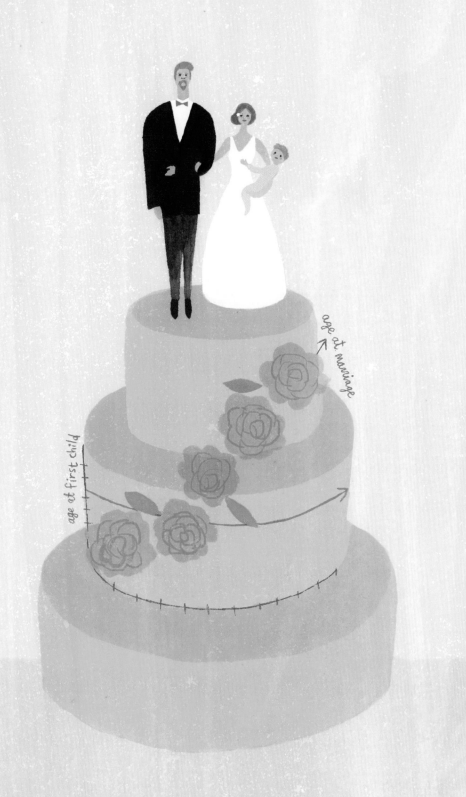

THE THIRD WAVE

This decade was nicknamed "the Good Decade," seen by many as a golden age of American culture defined by abundance, consumerism, a sense of happiness, youth culture, and the early development of the Internet. There was a sense of optimism, fun, and lightness: The young generation of the nineties saw themselves as the future.

The nineties also brought the rise of third-wave feminism, which sought to redefine what it meant to be a feminist. After the somewhat dormant complacency of the 1980s, women felt a renewed energy to fight for their rights. They criticized the unfinished work of the second-wave feminists, and asked women not to take past feminist achievements for granted. The third-wavers embraced individualism, diversity, and intersectionality. They spoke openly about sexuality and celebrated "girl power"[1] and independence.

In popular culture, there was a slew of empowering roles for girls and women—more than ever before.[2] Shows such as *Xena: Warrior Princess* (1995–2001) and *Buffy the Vampire Slayer* (1997–2003)[3] showcased strong female protagonists who battle powerful enemies, misogyny, and other injustices. Other shows, like *Sex and the City* (1998–2004) and *Ellen*[4] (1994–1998), openly addressed female sexuality. Some major legal, social, and political advancements were made as well: In 1993, there was a major Supreme Court case regarding sexual harassment in the workplace,[5] women's groups publicly tackled issues like domestic violence and rape, and more women than ever before were elected to Congress (see page 154). Power to the women!

★ 1990 ★

JUDITH BUTLER'S
GENDER TROUBLE

Gender Trouble: Feminism and the Subversion of Identity is one of the best-known works of the superstar philosopher Judith Butler (1956–). In the book, Butler argues that gender is not an innate personal attribute; instead, it is a social construct, or a kind of performance. In other words, there is no "real" feminine identity or masculine identity that people are born with; rather, they learn to act in a certain way from their environment. According to Butler, conventional ideas about gender and sexuality serve to perpetuate patriarchal structures as well as to justify the oppression of queer people. Therefore, we need to completely shift our basic notions about gender, in order to make society better. *Gender Trouble* is regarded as a foundational and highly acclaimed contribution to feminist and queer theory.[6]

★ 1991 ★

THELMA & LOUISE

The film *Thelma & Louise* was directed by Ridley Scott and written by Callie Khouri, who won an Oscar for her screenplay. It tells the story of two friends who go on a road trip: Thelma (Geena Davis) and Louise (Susan Sarandon). After killing a man who has tried to rape Thelma, the two women go on the run, committing other felonies along the way. In the famous last scene of the film (spoiler alert!), the two women are cornered in their car by the police. They decide against being captured and spending the rest of their lives in jail. So they kiss, step on the gas, and accelerate over a cliff and into the Grand Canyon. The film was a huge critical success, and many felt that it empowered women. However, it also caused controversy within feminist circles: some thought its portrayal of women was misogynistic. Furthermore, the film, with its all-white cast, was criticized for its lack of diversity. Even so, *Thelma & Louise* is regarded as an important feminist landmark, as it shows women taking action in the face of male aggression.[7]

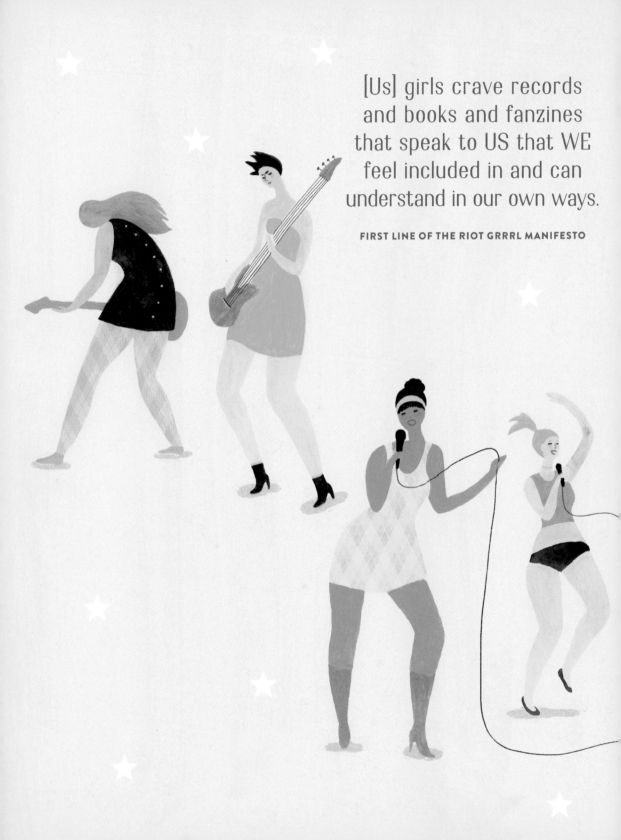

[Us] girls crave records and books and fanzines that speak to US that WE feel included in and can understand in our own ways.

FIRST LINE OF THE RIOT GRRRL MANIFESTO

★ 1991 ★

RIOT GRRRLS

In 1991, women started a punk movement of their own—without the boys! These all-female bands—such as Heavens to Betsy, Bikini Kill, and Bratmobile—became known as Riot Grrrls. Together they confronted sexism in the music world by blending feminist consciousness with punk style and politics. The Riot Grrrls held regular meetings to discuss music as well as their experiences with sexism, body image, and identity. They organized to end homophobia, racism, sexism, and especially physical and emotional violence against women and girls. The Riot Grrrls also created zines and cassette tapes that they distributed widely as a way of saying "Screw you!" to commercial magazine and music publishers.

★ 1991 ★

ANITA HILL

AND SEXUAL HARASSMENT AWARENESS

———

In 1991, attorney and law professor Anita Hill (1956–) stood up against sexual harassment. When Clarence Thomas, Hill's boss at the Department of Education and Equal Employment Opportunity Commission back in the early 1980s, was nominated to the Supreme Court, she was called upon to publicly testify. Hill accused Thomas of multiple counts of sexual harassment. She testified in front of an all-white, all-male Senate Judiciary Committee, who mocked and jeered her throughout her statement. In many ways, their attitude reflected society's dismissal of sexual harrassment and deeply rooted sexism, as well as highlighted the power of the white patriarchy.

Unfortunately, Hill's public and extremely brave testimony[8] did not stop Thomas from being confirmed to the Supreme Court,[9] but it generated an awareness of what sexual harassment looks like in the workplace. The Senate hearings and their outcome mobilized women to political action[10] and ultimately led to the passing of the Violence Against Women Act in 1994.[11]

★ 1992 ★

YEAR OF THE WOMAN

The year 1992 was a watershed moment for American women: voters elected more new women to Congress than in any previous decade. Four new female senators were elected, which tripled the female representation,[12] and a record number of forty-seven women were elected to the House of Representatives, twenty-four for the first time! This began a period of unparalleled advances for women in Congress, as well as the beginning of political success for minority women. These events prompted the press to call 1992 the "Year of the Woman."[13] American women's struggle for political power has been long and difficult. What finally brought on the "Year of the Woman"? Many factors.[14] Women were galvanized by rising feminist sentiments, the availability of funding to women candidates,[14] raised awareness of domestic and social issues, as well as Anita Hill's provocative testimony the year before (see page 152).

★ 1992 ★

CAROL ELIZABETH MOSELEY BRAUN

FIRST AFRICAN AMERICAN WOMAN ELECTED TO THE SENATE

Carol Elizabeth Moseley Braun (1947–) represented Illinois in Congress from 1993 to 1999. Elected as part of the "Year of the Woman" (see page 154), she was the first female African American senator, the first African American senator for the Democratic Party, and the first female senator from Illinois. That's a lot of firsts! For the duration of her time in Congress, she was a strong advocate for women's rights and civil rights, as well as for reforms in education and health care. She also campaigned for gun control. Following her tenure as senator, she served as an ambassador to New Zealand and Samoa. Today, she works as an attorney, consultant, and entrepreneur in the private sector.

MURPHY BROWN

"FAMILIES COME IN ALL SHAPES AND SIZES"[15]

Murphy Brown was a sitcom that aired on CBS from 1988 to 1998, for a total of 247 episodes. It was revived for a limited time in 2018. The program starred Candice Bergen as Murphy Brown, an investigative journalist and news anchor on a fictional news program. The 1991–92 season caused an uproar: Murphy became a single mother by choice, a huge step in the portrayal of women in popular culture. As a result, a curious incident happened, where fiction and reality blurred: Vice President Dan Quayle criticized Murphy's character for "mocking the importance of fathers by bearing a child alone."[16] Quayle's remarks triggered a public discussion of family values. In the 1992–93 season premiere of *Murphy Brown*, the characters reacted to Quayle's comments within the show itself. They produced a special episode that celebrated and brought public awareness to the diversity of the modern American family.

★ 1993 ★

THE JOY LUCK CLUB

———

When *The Joy Luck Club* premiered in theaters in 1993, Americans hadn't seen anything quite like it before. It was the only major motion picture in the last quarter century to center on an Asian American female experience (at the time, Asian characters in Hollywood were scarce and often boxed into stereotypical roles, such as martial artists).[17] Based on Amy Tan's bestselling 1989 novel and directed by Wayne Wang, the movie tells the stories of four American-born Chinese women and their complex and often fraught relationships with their immigrant mothers. *The Joy Luck Club* was a modest box-office success, and reception was mixed; the film was criticized for its orientalist portrayal of Chinese Americans, as well as its negative depiction of the male characters. But the movie gave a voice to a minority female subjectivity that had not yet been depicted in American cinema. Critics and viewers alike hoped it would be the first of many mainstream films to focus on Asian American stories.[18] Despite its flaws, and the inevitable burden of representation placed on such a film to speak to the diverse experiences of millions, *The Joy Luck Club* can be celebrated for its openly feminist perspective and the empowerment of its Chinese American female characters.

★ 1993 ★

TONI MORRISON

FIRST AFRICAN AMERICAN WOMAN TO WIN THE NOBEL PRIZE IN LITERATURE

Toni Morrison (1931–2019) wrote her first novel, *The Bluest Eye* (1970), in fifteen-minute bursts each day before going to bed. She was a single mother and that's all the free time she had. It took her five years to finish the manuscript. Talk about inspiring! In 1987, Morrison published her most celebrated novel, *Beloved*, which won the Pulitzer Prize for Fiction and was later adapted as a film starring Oprah Winfrey. Inspired by the true story of an enslaved African American woman, Margaret Garner, the book examines the lasting trauma of slavery and how it shapes the experience of American black women. In 1993, Morrison was presented with one of the most prestigious awards there is for a writer: the Nobel Prize in Literature. She was the first African American woman to receive this honor. In addition to being a writer, Morrison worked as an editor and a professor of writing for many years. In 2012, President Barack Obama presented Morrison with the Presidential Medal of Freedom to acknowledge her invaluable contribution to American literature.

★ 1996 ★

EVE ENSLER'S
THE VAGINA MONOLOGUES

The Vagina Monologues, a play by Eve Ensler (1953–), was written originally to celebrate femininity. It consists of fictional monologues presented by women of diverse ages, races, and sexualities, exploring themes such as consensual and nonconsensual sex, body image, genital mutilation, reproduction, and sex work. An immediate global success, *The Vagina Monologues* encouraged women to speak up about their own sexual experiences, particularly abuse. This mobilized the creators to evolve the play into a movement with the aim to end violence against women. In 2006, the *New York Times* called *The Vagina Monologues* "probably the most important piece of political theater of the last decade."[19] Though it was groundbreaking, some critiques of *The Vagina Monologues* accused it of conflating vaginas with women and not being sufficiently intersectional or sexually diverse. Nevertheless, theater groups, particularly those comprised of college students, have continued to mount productions of the controversial play.

THE NEW MILLENNIUM

Two words define the first decade of the new millennium: "the Internet." Media became completely democratized, with social-media platforms, blogs, and video and radio channels opening up for everyone to express their ideas and opinions. Anyone could become a celebrity. These developments completely changed the social and political arenas by bringing in multiple new voices.

This decade is also characterized by a heightened fear of terrorism after the 9/11 terrorist attacks on the World Trade Center in New York City and the Pentagon in Washington, D.C., which predicated the war in Iraq and Afghanistan. And in 2008, there was a big economic crash. After the lightness of the previous decade, this one was harsher: reality hit America in the face.

On the feminism front, there was a bit of an illusion that equality had been achieved and that feminist activism was not as necessary as before. However, things were not yet equitable for women in terms of income, employment, or representation. Consider the fact that while women made up more than 50 percent of all college undergraduates, they were still underrepresented among faculty and in positions of power in many industries.

This planted the seeds of fourth-wave feminism (see page 175). With the newly formed feminist blogosphere, the fourth-wavers became connected through and active on the Internet, able to disseminate their ideas. They celebrated intersectionality, diversity, queerness, and the female body. Thanks to their popularization of these ideas, more women than ever were able to identify with the movement.

BELL HOOKS'S
FEMINISM IS FOR EVERYBODY

—

bell hooks (1952–)'s *Feminism Is for Everybody* is a short, accessible introduction to feminist theory, meant to be read by all genders. Published in 2000, the book quickly became a feminist classic. bell hooks's aim was to rescue feminism from academic jargon and, more important, from its bad reputation. Professor, author, and intersectional feminist thinker, hooks addresses the reader in a direct and sometimes provocative manner. She shows that feminism is not a scary word, but rather a call for equal rights for everyone.

> Simply put, feminism is a movement to end sexism, sexist exploitation, and oppression.
>
> **BELL HOOKS**

FEMINISTING

FEMINISM GOES ONLINE

Feministing is one of the earliest feminist blogs to ever exist. Jessica Valenti (1978–), a feminist writer and journalist, along with her sister, Vanessa Valenti (1980–), an entrepreneur for social change, began *Feministing* in 2004. Jessica felt that the mainstream feminist discourse was excluding young feminists. She set out to make feminism more accessible to young women and to build a community where multiple voices could be heard. The blog, run by young feminists, quickly became popular thanks to its bold and unapologetic tone. According to the blog, "For over a decade, we've been offering sharp, uncompromising feminist analysis of everything from pop culture to politics and inspiring young people to make real-world feminist change, online and off."[1] *Columbia Journalism Review* called *Feministing* "head and shoulders above almost any writing on women's issues in mainstream media."[2]

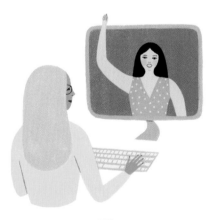

We are determined to stop this war on women.

**ELEANOR SMEAL, PRESIDENT
OF THE FEMINIST MAJORITY FOUNDATION**[3]

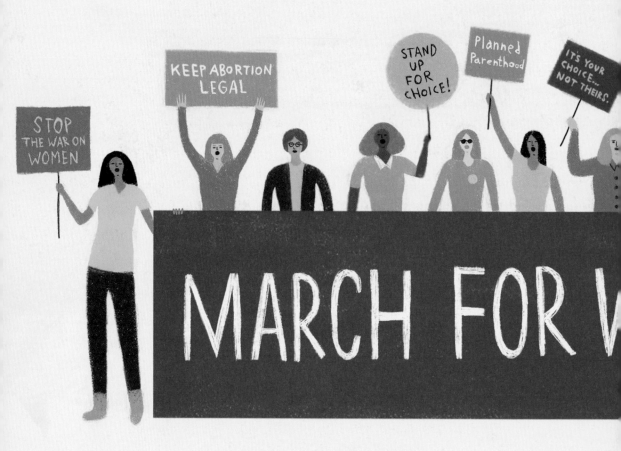

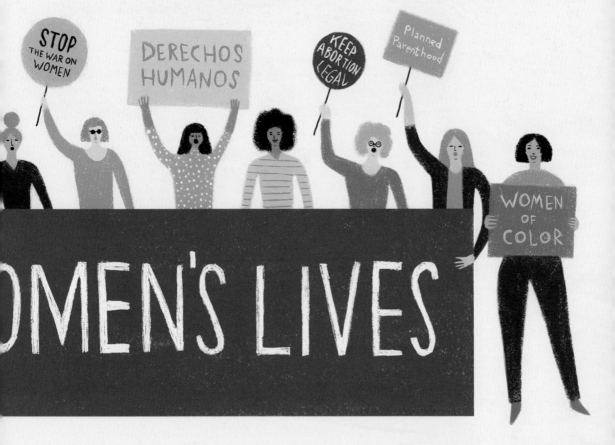

★ 2004 ★

MARCH FOR WOMEN'S LIVES

The March for Women's Lives was one of the largest pro-choice rallies in U.S. history, drawing an estimated one million people to Washington, D.C. The demonstration was held in response to new restrictions on abortion imposed by President George W. Bush.[4] The march's goal: to protect and promote access to a full range of reproductive health services, including abortion, birth control, and emergency contraception. This huge demonstration was organized by a coalition of women's rights and social justice groups, including the National Organization for Women (NOW), the Black Women's Health Imperative, the Feminist Majority Foundation, NARAL Pro-Choice America, the National Latina Institute for Reproductive Health, Planned Parenthood, and the American Civil Liberties Union. The rally was attended by activists from all over the country, as well as many celebrities who supported the cause.

CONDOLEEZZA RICE

FIRST BLACK FEMALE SECRETARY OF STATE

Dr. Condoleezza Rice (1954–) is one accomplished—and busy!—lady. In 2001, she became President George W. Bush's national security advisor—the first woman to serve in that position. Then, in 2005, during President Bush's second term, she became the first female African American secretary of state. During her tenure, she traveled more than any other secretary of state. Rice called her diplomatic style "Transformational Diplomacy," placing U.S. diplomats in areas of major social and political turmoil (such as the Middle East) in order to promote stability, health, and peace. After retiring from government in 2009, she returned to academia[5] and became a faculty member of the Stanford Graduate School of Business and a director of its Center for Global Economy and Business. She has authored many books, been awarded numerous honorary doctorates, and served on the board of several corporations.

★ 2006 ★

INDRA NOOYI
FIRST FEMALE CEO OF PEPSICO

Indra Nooyi (1955–) is a rock star. And not only because she used to play guitar in a rock band in her native India, but also because she was the first female CEO of PepsiCo, a giant global corporation.[6] Nooyi earned her master's degree at the Yale School of Management and has worked at PepsiCo since 1994. She moved up the ranks until she became president and then the first female CEO, in 2006. In this role, which she held until 2018, Nooyi championed innovations in environmental sustainability, promoted the company's globalization, and shifted its product portfolio to include healthier options. Her leadership led PepsiCo to a significant financial recovery. Nooyi is consistently included in *Forbes*'s list of the world's one hundred most powerful women.[7]

DREW GILPIN FAUST

MADAME PRESIDENT

In 2007, Drew Gilpin Faust (1947–) became the first (and to date only) woman president[8] of Harvard University, one of the world's most prestigious academic institutions.[9] She served in this role until 2018. She is the author of six books and the recipient of the prestigious John W. Kluge Prize for Achievement in the Study of Humanity, which the Library of Congress awards to "work of the highest quality and greatest impact that advances understanding of the human experience."[10] Faust's appointment followed the departure of Lawrence Summers in 2006, who resigned after his highly controversial statement that the under-representation of women in the sciences could be due to a "different availability of aptitude" rather than discrimination and socialization. Harvard—horrified—hurried to put a woman at its helm. One of Faust's first initiatives was to significantly increase financial aid for students, in order to make Harvard a more diverse institution. During her tenure, Faust also raised more money for Harvard than any of her male predecessors.

★ 2008 ★

THE FOURTH WAVE

#FEMINISM

To be clear, not everyone agrees about the waves of feminism, their time-lines, or what defines them. Not everyone likes the term "waves," which implies organized and unified movements. People don't even agree about what it means to be a feminist in the first place! That being said, the notion of feminist waves is often useful in understanding American feminist history and the issues tackled by each generation of feminists. Feminist thinkers point to the year 2008[11] as the beginning of fourth-wave feminism. For the first time, feminism was heavily shaped by and organized through digital media. The Internet became feminism's new frontier, and the online presence helped make it a global movement. Beforehand, the Internet (and computers in general) were considered men's territory, as most computer engineers were male. Social media opened the Internet for women and enabled them to connect, interact, and organize in new ways around issues such as intersectionality and queer identities. The Internet also enabled the fourth-wavers to publicly call out sexism and misogyny.[12] This wave of feminism is body-positive, sex-positive, and trans-inclusive, and strives to make feminism accessible to all.

★ 2009 ★

"THE BATTLE OF THE SEXES IS OVER"

————

In 2009, *Forbes* declared the "battle of the sexes" had ended, citing the Center for American Progress to detail that "for the first time in history, women are half of all U.S. workers and mothers are the primary breadwinners or co-breadwinners in two-thirds of American families."[13] This statistical achievement reflects the remarkable shift in women's roles in the past decades. However, there were still gender gaps in the workforce. Support for working mothers was not yet sufficient, and women still earned less than men. The battle was not quite over yet!

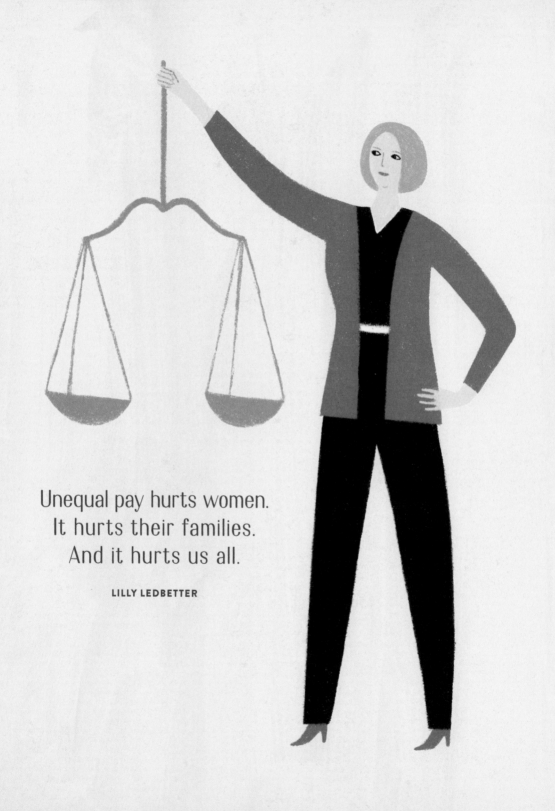

Unequal pay hurts women.
It hurts their families.
And it hurts us all.

LILLY LEDBETTER

★ 2009 ★

EQUALITY IN THE WORKPLACE

THE LILLY LEDBETTER FAIR PAY ACT

———

The Lilly Ledbetter Fair Pay Act, passed in 2009, was the first bill signed into law by President Barack Obama.[14] This act was an important step in closing the gender-based wage gap that has persisted for decades, even after the Equal Pay Act of 1964 (see page 94). In 1998, Lilly Ledbetter (1938), a production supervisor at a Goodyear tire plant, filed a lawsuit regarding pay discrimination. The Supreme Court in *Ledbetter v. Goodyear Tire & Rubber Company* (2007) ruled against Ledbetter and severely restricted the time period for filing complaints of discrimination concerning wages.[15] The Fair Pay Act overturned this decision. So what did this mean? Employees could now challenge unfair pay retroactively, even if they were not initially aware that they were being discriminated against. This act helps prevent wage disparity and allows women to better fight against gender-based discrimination.

★ 2009 ★

THE BIG REVERSAL
SINGLE > MARRIED

———

In 2009, the proportion of married women in the U.S dropped below 50 percent. For the first time in American history, single women outnumbered married women.[16] The Population Reference Bureau called this phenomenon a "dramatic reversal."[17] Single ladies were on the rise! The census showed that women were also getting married later. In other words, women were spending more of their lives independent. Today, only 20 percent of Americans are wed by age twenty-nine, compared with nearly 60 percent in 1960. The rise of the single woman is significant: in the past, women were expected to marry early, and their roles in society were shaped largely by their husbands' socioeconomic position. Now that women were increasingly autonomous, their roles were being redefined, and as a large group they had the potential to change the public sphere more than ever before. They gained a new political power to fight for initiatives to improve women's lives.[18]

FEMINISM IS TRENDING

This decade began with optimism and some promising leaps forward: LGBTQAI rights achieved a huge win with the federal legalization of gay marriage (see page 190). Women's rights in the workforce also improved, with new laws such as "reasonable break time" (see page 185). "Period activism" in recent years has led to innovations in menstrual products, as well as legislation that makes them more affordable and accessible.[1] In the sports arena, we saw the rise of powerful female athletes like the tennis player Serena Williams, who has the "best serve ever in the history of women's tennis,"[2] and the gymnast Simone Biles, who is the most decorated gymnast in America.[3] In popular culture and media, women of color made huge strides with such titans as Beyoncé, who was the first artist ever to top the charts with her first six albums (see page 193), and Shonda Rhimes, the first African American woman to create and produce a top-ten network series.[4] Other prominent examples include Mindy Kaling's *The Mindy Project*[5] (2012) and Issa Rae's *Insecure* (2016), two groundbreaking TV shows created by and starring women of color.

The second half of the decade, however, has seen a great deal of political and social turmoil. In response to a more conservative federal government, there has been a renewed feminist fervor, and the digitally driven fourth-wave feminists have unabashedly made their voices heard. One of their biggest issues has been openly exposing and condemning sexual harassment and violence against women, as in the cases of the #MeToo and Time's Up movements (see page 198). Others have been embracing all facets of the feminine experience and celebrating women's bodies and reproductive rights.

Feminism has become hot again. Millennials (the generation born between 1981 and 1996) have adopted feminist culture, and celebrities openly declare themselves to be feminists. In contrast with past decades, "feminist" is no longer an identity that women shy away from.[6] Gloria Steinem, the longtime feminist leader and activist, says that today's feminism, compared with that of the past, is "way more universal and self-perpetuating."[7]

MOMS AT WORK

REASONABLE BREAK TIME

———

Working mothers have not had an easy time in the American workforce. From restricted family leave to expensive childcare, juggling motherhood and a career can be challenging, to say the least. Being a working mother changed for the better with the 2010 passage of the "reasonable break time law" of the Fair Labor Standards Act. This provision requires employers to "provide reasonable break time for an employee to express breast milk for her nursing child for one year after the child's birth each time such employee has need to express the milk."[8] Employers are also required to provide a private place—other than a bathroom—where the employee can pump breast milk. This long overdue provision allows women to both return to work and continue breast-feeding, and helps a little with balancing motherhood and career.[9]

★ 2010 ★

KATHRYN BIGELOW

FIRST WOMAN TO WIN AN OSCAR FOR BEST DIRECTOR

Standing ovation for Kathryn Bigelow (1951–)! In 2010, Bigelow, a film director, producer, and writer, became the first (and, as of 2019, the only) woman to win an Academy Award for Best Director. Since 1929, when the first Academy Awards ceremony was held, only five women have ever been nominated for best director. Bigelow won for *The Hurt Locker*, a low-budget thriller about the war in Iraq and its psychological effects on soldiers. Bigelow is one of the most influential women in Hollywood and is known for being a female pioneer in the male-dominated world of action movies. She does not hesitate to go to extremes. For *The Hurt Locker*, Bigelow filmed in Jordan, sometimes as close as three miles from the Iraqi border, in heat that reached the crazy temperature of 110 degrees.[10] In her films, she strives to tell stories that are relevant, entertaining, and substantive.

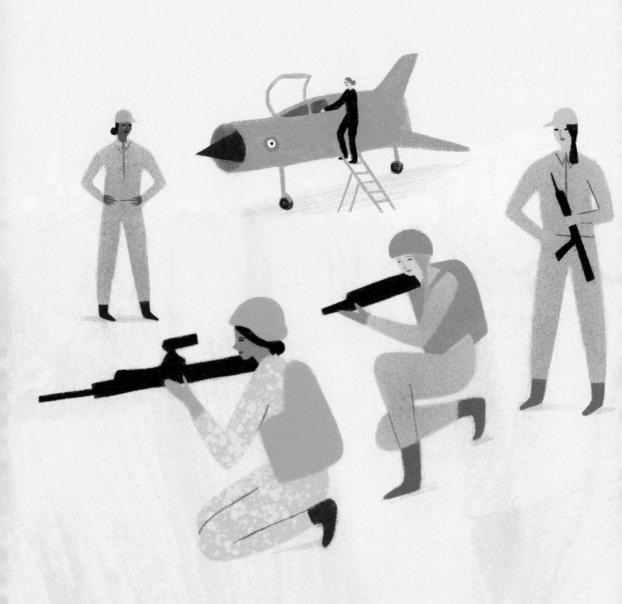

★ 2013 ★

THE RIGHT TO FIGHT

THE PENTAGON REMOVES BAN ON WOMEN IN COMBAT

In 2013, the American military underwent a paradigm shift. The Department of Defense lifted the ban on female service members in combat roles. This groundbreaking decision overturned a 1994 Pentagon rule that restricted women from artillery, armor, infantry, and other combat roles.[11] Though women have enlisted in the military for decades (by 2013 they made up about 15 percent of active-duty military), the vast majority of them served in auxiliary positions. Lifting the ban removed the remaining barrier to a fully inclusive military, making hundreds of thousands of front-line jobs open to women. Women are now able to drive tanks, fire mortars, and lead infantry soldiers into combat. This policy change was due in large part to the heroism exhibited by women serving in Iraq and Afghanistan.[12]

★ 2015 ★

LOVE IS LOVE
SAME-SEX MARRIAGE

After years and years of struggle by the LGBTQAI community, same-sex marriage was finally legalized in all fifty states. In 2015, in the Supreme Court case *Obergefell v. Hodges*, the justices ruled 5–4 that same-sex marriage is a constitutional right, guaranteed under the Fourteenth Amendment.[13] Jim Obergefell, an Ohio native, sued his state for the permission to be listed as the surviving spouse on his terminally ill husband's death certificate. His claim went on to make history in the Supreme Court. Legalizing gay marriage is one of the most important civil rights landmarks of recent years. As then President Obama said about the case, "This ruling is a victory for America."

THE FIRST WOMEN'S MOSQUE IN AMERICA

The first female-only mosque in the United States opened in 2015 in Los Angeles. Once a month, women gather for the *jumma'a*, or Friday prayer, which is led by women, for women—in contrast with traditional Islamic mosques, where women are separated from men by a partition and men lead the service. The Women's Mosque of America's mission is "to uplift the Muslim community by empowering women and girls through more direct access to Islamic scholarship and leadership opportunities."[14] The mosque has a large focus on inter-religious dialogue, pluralism, and diversity.

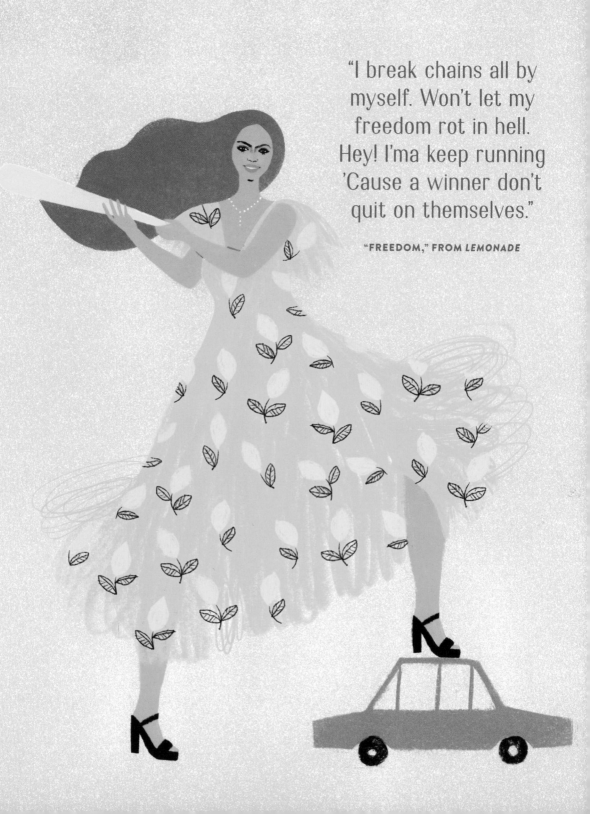

"I break chains all by myself. Won't let my freedom rot in hell. Hey! I'ma keep running 'Cause a winner don't quit on themselves."

"FREEDOM," FROM *LEMONADE*

BEYONCÉ'S *LEMONADE*

———

In 2016, Queen B dropped her album *Lemonade* without warning. Beyoncé Knowles-Carter (1981–)—the world-famous singer, songwriter, producer, and actress—had already become the highest-paid black musician ever in 2014. That same year, throughout her Mrs. Carter Show World Tour, she performed in front of a huge sign that read FEMINIST, a move that gave her public persona a new sense of political gravitas. *Lemonade*,[15] her most ambitious project yet, followed suit. The concept album includes twelve tracks and a one-hour film that premiered on HBO. Alternatively celebrating and grappling with black heritage, *Lemonade*'s lyrics and visuals proudly take their inspiration from Southern and black culture without shying away from the struggles black people (and black women in particular) have faced in America. Prominent references are made to the Black Panthers and the Black Lives Matter movement,[16] and one video includes a snippet of Malcom X's declaration that "the most disrespected person in America is the black woman." *Lemonade* is also highly personal and emotional, portraying Beyoncé's relationship with her husband, Shawn Carter (aka Jay-Z), as they navigate marriage in light of his infidelity. Beyoncé's openness and courage to discuss these issues in public can be seen as radical feminist acts in and of themselves.[17]

HILLARY CLINTON

FIRST FEMALE PRESIDENTIAL NOMINEE
OF A MAJOR POLITICAL PARTY

———

Hillary Clinton (1947–) will always be remembered as the woman who almost became president. She was the first female candidate to be nominated for president by a major U.S. political party. Although she won the popular vote, she lost the presidential election to Republican opponent Donald Trump. Clinton, married to President Bill Clinton, was the First Lady from 1993 to 2001. During her tenure as First Lady, she advocated for gender equality and health-care reform.[18] Trained as a lawyer at Yale, Clinton later served as a Democratic senator from New York and as the secretary of state during President Barack Obama's administration, making her the first former First Lady to be elected to the U.S. Senate and to hold a federal cabinet-level position. Following her devastating loss in the 2016 election, she wrote her third memoir, *What Happened*, analyzing her defeat. Clinton went on to found Onward Together, a political organization dedicated to fund-raising for progressive political groups and to building "a fairer, more inclusive America."[19]

★ 2017 ★

THE WOMEN'S MARCH

———

"I am woman, hear me roar!" The Women's March on January 21, 2017, was a tour de force protest movement to advocate for women's rights, health-care reform, immigration, environmental issues, LGBTQAI rights, racial equality, freedom of religion, and workers' rights. It was organized by a diverse group of women who joined together and formed the Women's March organization.[20] The largest march took place in Washington, D.C., with sister marches in cities across the country and the world. These demonstrations were a reaction to the inauguration of President Donald Trump, whose chauvinistic rhetoric is seen as offensive by many women. Protesters made a strong visual statement by wearing pink "Pussyhats" as a representation of united female power and a positive appropriation of the word "pussy," which President Trump had previously used in a derogatory way.[21] The hope was that the march would spark a movement and become a unifying force in a highly politically polarized America. It was the largest single-day protest in U.S. history, and was attended by an estimated five million people around the world.

ME TOO & TIME'S UP

———

In 2017, the #MeToo hashtag went viral,[22] leading to a long-overdue national conversation about sexual violence. Women became empowered to speak up about their personal harassment stories, including ones involving prominent public figures. In the past, accounts of harassment were often swept under the rug, but now, in large part thanks to the public nature of #MeToo, silencing of victims was no longer tolerated. The "Me Too" movement was originally created by Tarana Burke, an activist and a survivor of sexual violence, in Harlem in 2006 as a grassroots support network. Her mission was to support survivors of sexual violence, particularly low-income women and women of color.[23] She said, "['Me too'] was a catchphrase to be used from survivor to survivor to let folks know that they were not alone and that a movement for radical healing was happening and possible."[24] The movement has since become a global network of women from all walks of life, with the goal to end sexual violence.[25]

In November 2017, a letter of solidarity to victims of sexual harassment[26] was written by the Alianza Nacional de Campesinas, a network of female farmworkers across the United States. The letter was published in *Time* and described their experiences with sexual harassment. In response to so many women speaking up,[27] in 2018, more than three hundred Hollywood celebrity women formed Time's Up. According to them, "The clock has run out on sexual assault, harassment and inequality in the workplace. It's time to do something about it." Recognizing their place of privilege, these women set out to create a legal defense fund to provide legal help and public relations support to survivors of sexual harassment, so that they can "take back their power, seek justice, and make their voices heard."[28]

★ 2018 ★

THE PINK WAVE

———

The year 2018 marked a sea change for women in politics. A record number of women were elected in the midterm elections, creating a "Pink Wave"[29] and making 2018 the "Year of the Women."[30] The previous record was eighty-four women in Congress, but in 2018 more than 110 women were elected, out of which forty-three[31] were women of color. In addition, there were many firsts, among them the first Muslim women,[32] first Native American women,[33] and first openly bisexual woman senator.[34] In addition to that, a woman became the youngest person ever elected to Congress.[35] The surge in female candidates can be attributed in part to the rising frustration and outrage among women regarding their rights, welfare, and safety, which also contributed to the founding of the #MeToo and Time's Up movements (see page 198). The great news? Researchers have found that women are more likely to introduce legislation that helps other women. They also get more done: Studies show that women sponsor more bills, as well as bring more money back to their districts. And, importantly, women in Congress serve as an inspiration for future generations of women to become politically engaged.[36]

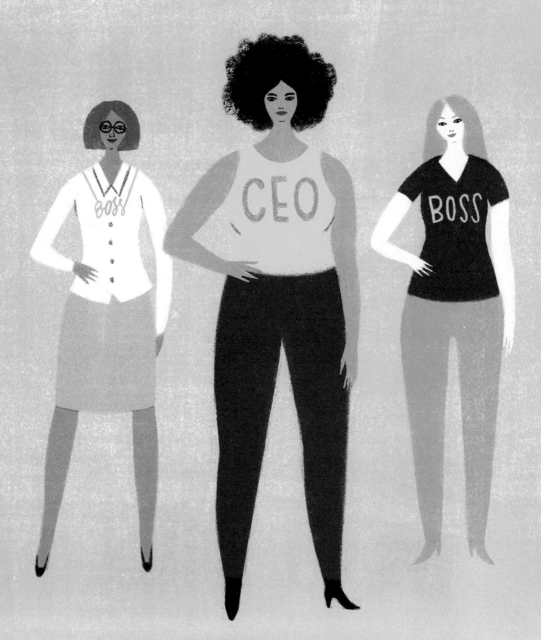

Advancing the rights and opportunities
of women and girls is the great unfinished
business of the twenty-first century.

HILLARY CLINTON

LEAD THE CHARGE, LADIES!

—

WHAT A CENTURY!

The past one hundred years have seen the lives of American women vastly improved: from greater gender equality, both culturally and legally, to stronger representation in popular media, business, and politics.

But! There is still so much to be done. There has never been a woman as head coach of a major sports team, as chief justice of the Supreme Court, as director of the FBI or CIA, as CEO of a top-five Fortune 500 company—or as president or vice president.

And that's not all. We still don't have global maternity leave and affordable child-care. Women still don't make as much money as men for equal work. Domestic abuse, sexual assault, and human trafficking are still rampant and devastating to the girls and women affected.

And, ladies: we still have work to do among ourselves! We must address divisions over issues of race and prejudice, class and poverty, sexuality and gender identity. We must treat one another with compassion and with respect for our differences, for our unique identities and experiences.

So—let's look forward and lead the charge! Be brave enough to stand up and speak out for better lives for women. Take the amazing, inspiring examples in this book and use them to launch the next one hundred years.

Let's make equal opportunity and rights for everyone not just a slogan—but a reality.

Our foremothers have shown us what is possible. Their story is also our story. Let's carry it forward.

★ Notes ★

CHAPTER 1: 1920S

1. The first wave of feminism in America was roughly the period 1848–1960 and focused largely on women's suffrage. (It began with the Seneca Falls Convention—the first women's rights convention in the United States. Some see it as ending earlier, with waning feminist activity after suffrage was gained.) The term "waves of feminism" was actually coined retroactively only in 1968 (see chapter 5, note 2).

2. Rebecca Latimer Felton (1835–1930) was a writer and suffragist from Georgia. She became the first female senator in 1922 but only served for one day (making her the senator with the shortest term, too). She was appointed to fill a vacancy left by the sudden death of a Georgia senator, as her appointers knew she would not pose a threat to the other candidates. Felton served in the Senate for twenty-four hours until a special election was held to elect a new senator. See https://www.georgiaencyclopedia.org/articles/history-archaeology/rebecca-latimer-felton-1835-1930.

3. This is the only place in the entire Constitution where the word "sex" appears and gender is addressed.

4. This Amendment was also called "The Susan B. Anthony Amendment." Susan B. Anthony (1820–1906) was a suffragist, abolitionist, and activist, who traveled broadly advocating for women's rights, and worked hard her whole life to pass the suffrage amendment.

5. Minority women still faced obstacles. Women of Asian descent were not granted citizenship until the 1940s (Chinese and Filipinos) and 1950s (Japanese), so they couldn't vote until then. Native American women were granted citizenship in 1924, but many states prohibited their voting rights until the 1950s. Black women, especially in the South, also faced obstacles when attempting to vote during this time. It wasn't until the Voting Rights Act of 1965 that this kind of voter discrimination was addressed on a national scale. Women with disabilities faced difficulties as well: only in 1990 were polling centers required to make accommodations for people with disabilities, thanks to the Americans with Disabilities Act.

6. Many women fought for the right to vote throughout the years. One of the leaders at the time, and a principal force in the ratification of the Nineteenth Amendment, was Alice Paul (1885–1977), who led demonstrations for suffrage and was even imprisoned for her activism.

7. Although this group fought for equal rights regardless of sex, unfortunately the motives of some were powered by racist sentiments. Many were outraged that men of color were granted the right to vote before white women (according to the Fifteenth Amendment to the Constitution in 1870). For example, Susan B. Anthony said, "I will cut off this right arm of mine before I will ever work or demand the ballot for the Negro and not the woman." See more in Sarah Jones, "The Complicated History of the Suffragette Movement," Minutes, *New Republic*, January 20, 2016, https://newrepublic.com/minutes/138512/complicated-history-suffragette-movement.

8. Many women did not exercise their right to vote in the first election, as only about 36 percent voted in the 1920 election immediately following the ratification. See more about women's early voting history in the United States in J. Kevin Corder and Christina Wolbrecht, *Counting Women's Ballots: Female Voters from Suffrage through the New Deal* (New York: Cambridge University Press, 2016).

9. See Global Women's Leadership Initiative staff, "Woodrow Wilson and the Women's Suffrage Movement: A Reflection," Wilson Center, June 4, 2013, https://www.wilsoncenter.org/article/woodrow-wilson-and-the-womens-suffrage-movement-reflection/.

10. Jeannette Rankin was the first woman elected to Congress in 1916.

11. Margaret Sanger was a controversial figure. She lobbied for reproductive rights but was also a eugenicist, with the mission to improve the fitness of humankind through selective breeding—or, in other words, birth control.

12. "Principles and Aims of the American Birth Control League," appendix to Margaret Sanger, *Pivot of Civilization* (New York: Brentano's, 1922), 277.

13. *The Birth Control Review* was founded by Sanger in 1917 and published until 1940.

14. There were some disposable napkins available before this, such as the "Lister's Towel" by Johnson and Johnson in 1897, but these were not

widely used or advertised. According to communications scholar Roseann Mandziuk, "Kotex was such a departure because there just wasn't a product." See https://www.smithsonianmag.com/innovation/surprising-origins-kotex-pads-180964466/, and learn more in Elissa Stein and Susan Kim, *Flow: The Cultural Story of Menstruation* (2009).

15. Historically, women have been shamed for their bodily functions and encouraged to hide them from sight. Initial Kotex products and ads can be viewed as first steps toward embracing women's bodies, something that is still being fought for today, such as in "The Year of the Period" (see Chapter 10, p. 182).

16. *The Flapper* was a small publication based out of Chicago. Its tagline was "Not for Old Fogies."

17. The origin of the term "flapper" is unknown. Some think it likens a woman to a young and wild bird trying to fly.

18. Per its website, the NAS is "a "non-profit society of distinguished scholars. Established by an Act of Congress, signed by President Abraham Lincoln in 1863, the NAS is charged with providing independent, objective advice to the nation on matters related to science and technology." The NAS only included men until 1925.

19. Ederle won a gold medal in the 1924 Summer Olympics in Paris as part of the U.S. swim team in the 4×100-meter freestyle relay.

CHAPTER 2: 1930S

1. Twenty-six states had laws prohibiting employment for married women! From Deborah G. Felder, *A Century of Women* (New York: Citadel Press, 2003), 144.

2. Some of the services provided included childcare, night school for adults, a public kitchen, a gymnasium, and even an art gallery. By its second year, Hull-House accommodated two thousand people every week. Read more about Jane Addams at www.nobelprize.org/prizes/peace/1931/addams/biographical/.

3. Coined in *Vogue*, December 1933. From Doris L. Rich, *Amelia Earhart: A Biography* (Washington, DC: Smithsonian Books, 1996), 30–31.

4. Lindbergh was the first man to fly solo over the Atlantic Ocean, in 1927.

5. For more about the ERA, see Chapter 6, note 3.

6. Susan M. Hartmann, "Caraway, Hattie Ophelia Wyatt," in *American National Biography (ANB)* 4 (New York: Oxford University Press, 1999), 369–70.

7. Eleanor was also the niece of President Theodore Roosevelt. She was the fifth cousin once removed of her husband, Franklin Delano Roosevelt.

8. Read more: Lillian Patton and Thomas Patton, "Eleanor Roosevelt's 'Education for Citizenship,'" *Social Studies* 75, no. 6 (Nov.–Dec. 1984): 236–39.

9. See more at the Lettie Pate Evans Foundation's site, lpevans.org, and the Lettie Pate Whitehead Foundation's website, lpwhitehead.org.

10. See more in Felder, *A Century of Women*, 154.

11. From the website of Iota Delta Phi Sorority, https://iota-deltaphi.org/partners, and Broward County NCNW: http://browardncnw.org/programs/.

12. A 2014 Harris Poll suggested *Gone with the Wind* was the second-favorite book of American readers, just after the Bible. https://theharrispoll.com/new-york-n-y-april-29-2014-theres-always-one-it-might-be-something-you-remember-fondly-from-when-you-were-a-child-or-it-could-be-one-that-just-resonated-with-you-years-after-your-first-expe-2/.

13. Rowbotham is quoted in Felder, *A Century of Women*, 158.

14. At the time, birth control consisted mostly of different barrier methods. For example, a diaphragm, also known as a "womb veil," was inserted into the cervix to stop sperm. There were also early forms of IUDs (intra-uterine devices), inserted into the uterus by a doctor. Condoms were used as well. See excerpt from *Our Bodies Ourselves*: https://www.ourbodiesourselves.org/book-excerpts/health-article/a-brief-history-of-birth-control/,

and Planned Parenthood report: https://www.plannedparenthood.org/files/2613/9611/6275/History of_BC_Methods.pdf. You can also read more in Peter C. Engelman, *A History of the Birth Control Movement in America* (New York: Praeger, 2011).

1. There were several campaigns designed to bring women into the workforce: "Women in the War," for war-related jobs; and "Women in Necessary Services," for auxiliary jobs that were crucial for the home front. From Maureen Honey, *Creating Rosie the Riveter: Class, Gender and Propaganda during World War II* (Amherst: University of Massachusetts Press, 1984), 39–40.

2. Mary M. Schweitzer, "World War II and Female Labor Force Participation Rates," *Journal of Economic History* 40, no. 1 (March 1980): 89–95.

3. Unfortunately, after the war, women were forced to leave the labor force, to make room for the men returning from battle. For example, in the auto industry the percentage of women on the assembly lines fell drastically postwar. See Schweitzer, *World War II and Female Labor Force Participation Rates*.

4. Bikinis were invented by French fashion designer Louis Réard. This fashion item generated much controversy; on the one hand, it could be seen as liberating women to expose their skin and dress freely. On the other hand, it could be viewed as encouraging the objectification of the female body.

15. As we've seen, in regard to the establishment of the ABCL (see page 19), Sanger's motives weren't only to promote women's rights. (See Chapter 1, note 10.)

16. When the first birth control pill came on the market. (See page 88.)

17. For more, see Felder, *A Century of Women*, 165.

CHAPTER 3: 1940S

5. There is a more nuanced statistical breakdown available for women of color, married women, etc. See more in Susan M. Hartmann, *The Home Front and Beyond: American Women in the 1940s* (Boston: Twayne Publishers, 1984), 77–95.

6. Though women gained access to new jobs, industrial women workers still made an average weekly wage of $31.21, while skilled male workers earned $54.65. From Hartmann, *The Home Front and Beyond*, 87.

7. The majority of which were in defense industries. Hartmann, *The Home Front and Beyond*, 86.

8. Margot Lee Shetterly, *Hidden Figures: The American Dream and the Untold Story of the Black Women Mathematicians Who Helped Win the Space Race* (New York: William Morrow, 2016).

9. This would later become DC Comics. Wonder Woman made her debut in 1941 but didn't get her own solo comic book until 1942.

10. When *Wonder Woman* was first released, there was plenty of controversy. In March 1942, the National Organization for Decent Literature blacklisted the comic under "Publications Disapproved for Youth" for one reason: "Wonder Woman is not

18. A collection of Horney's early writings was published posthumously, in 1967, as *Feminine Psychology*.

19. Read more in Susan Tyler Hitchcock, *Karen Horney: Pioneer of Feminine Psychology* (New York: Chelsea House Publishers, 2004).

sufficiently dressed." From Jill Lepore, "The Surprising Origin Story of Wonder Woman," *Smithsonian*, October 2014, www.smithsonianmag.com/arts-culture/origin-story-wonder-woman-180952710/.

11. She was drawn originally by the artist Harry G. Peter.

12. Marston was inspired by Sanger's book *Motherhood in Bondage*, about freeing women from the shackles of unwanted babies by using birth control. Marston repeatedly portrayed Wonder Woman in scenes of bondage in order to reflect these ideas. Another connection: Marston was polyamorous and had a romantic relationship with Olive Byrne, Margaret Sanger's niece and his former student, while married to Elizabeth Holloway. Learn more in Jill Lepore, *The Secret History of Wonder Woman* (New York: Alfred A. Knopf, 2014).

13. Who served as the artist's inspiration for Rosie? The answer is disputed. According to some, the real Rosie was Naomi Parker Fraley, who worked at Alameda Naval Air Station during World War II. However, others claim his muse was Geraldine Hoff Doyle, who worked as a metal presser at an automobile factory in Michigan.

14. Some see Rosie not as a feminist icon, but as manipulative propaganda by the government to recruit women to the war effort while paying them very low wages. On top of that, there was an expectation that they would leave these jobs once men returned. See more in this interesting article: Sarah Myers and G. Kurt Piehler, "The Untold Story of the Iconic Rosie the Riveter Poster," *Fast Company*, June 21, 2018, www.fastcompany.com/90176641/the-untold-story-of-the-iconic-rosie-the-riveter-poster/.

15. Originally formed in 1942, this unit was an auxiliary branch titled "Women's Army Auxiliary Corps" (WAAC). In 1943 it became an active duty unit and was renamed "Women's Army Corps" (WAC). In 1978, the WAC was totally integrated into the male units.

16. SPARS, named by the first director of the Women's Reserve, Dorothy C. Stratton, is an acronym for the Coast Guard's motto, "Semper Paratus"—"Always Ready."

17. From Felder, *A Century of Women*, 172, and Kathryn Sheldon, "Brief History of Black Women in the Military," The Women's Memorial, www.womensmemorial.org/history-of-black-women/.

18. Elizabeth L. Maurer, "The Bravery of Army Nurse Annie G. Fox at Pearl Harbor," National Women's History Museum, December 5, 2016, www.womenshistory.org/articles/bravery-army-nurse-annie-g-fox-pearl-harbor/.

19. Previously, women played baseball in different settings such as in "factory leagues," but this was the first professional league. It is important to note that this was an all-white league; there was a separate black league at the time.

20. Learn more in Kathryn Cullen-DuPont, *The Encyclopedia of Women's History in America*, 2nd ed. (New York: Facts on File, 2000).

21. From a season-opening letter to the players, wherein Black explains the league's philosophy. From David

C. Ogden and Joel Nathan Rosen, eds., *A Locker Room of Her Own: Celebrity, Sexuality, and Female Athletes*, (Jackson: University Press of Mississippi, 2013), 23–42.

22. For more about the emerging teen culture, see Grace Palladino, *Teenagers: An American History* (New York: Basic Books, 1997).

23. From Valentine's first editorial letter, "SEVENTEEN Says Hello." To read the entire letter and learn more about the magazine's history, see Kelley Massoni, *Fashioning Teenagers: A Cultural History of* Seventeen *Magazine* (Walnut Creek, CA: Left Coast Press, 2010).

24. There were a number who criticized it: Margaret Mead, a leading anthropologist of the time, commented that the attack on the feminist movement was unwarranted and inconsistent, as it portrayed women as both the victims of feminism and the cause of their own unhappiness. And yet, even Mead agreed with many of the book's arguments.

CHAPTER 4: 1950S

1. The term "nuclear family" was revived during the Cold War era and used to describe the family as the essential building block of a strong and healthy society.

2. Although the show received good reviews, it was canceled after just a few months because Scott's name was included in an anti-communist newspaper. This left her show without a sponsor. For more, see Donald Bogle, *Primetime Blues: African Americans on Network Television* (New York: Farrar, Straus and Giroux, 2001).

3. Adam Clayton Powell Jr. was a Baptist pastor and an American politician,

who represented Harlem, New York City, in the U.S. House of Representatives. He was New York's first African American congressman.

4. Read more in her autobiography, *Christine Jorgensen: A Personal Autobiography* (New York: Bantam Books, 1967).

5. Deborah G. Felder, *A Century of Women* (New York: Citadel Press, 2003), 209.

6. For more, see Felder, *A Century of Women*, 206–10.

7. Said on her seventy-seventh birthday, according to "Women of the Hall:

Rosa Parks," *Women's National Hall of Fame* (undated).

8. Earlier in the year, two civil rights activists, George W. Lee and Lamar Smith, were assassinated in separate incidents in Mississippi. Shortly after Smith's death, fourteen-year-old Emmett Till was brutally murdered after a white woman accused him of flirting with her.

9. From https://www.archives.gov/education/lessons/rosa-parks.

10. Nine months prior, Claudette Colvin, who was a teenage schoolgirl at the time, refused to get up from her seat for white passengers. As a

result, she was dragged off the bus in handcuffs. Colvin went on to become the key witness in the Supreme Court case of *Browder v. Gayle*, the case that eventually ended the bus segregation in Alabama (after Parks's case stalled in the appeals process). Read more in Phillip Hoose, *Claudette Colvin: Twice Toward Justice* (New York: Square Fish, 2010).

11. Rosa Parks worked at the National Association for the Advancement of Colored People (NAACP) as a secretary from 1943 until 1956. One of the things she worked on was the investigation of the 1944 gang rape of a black woman named Recy Taylor.

12. Read more in her autobiography, *Rosa Parks: My Story* (New York: Puffin Books, 1999).

13. Dennis Bingham, "'Before She Was a Virgin . . .': Doris Day and the Decline of Female Film Comedy in the 1950s and 1960s," *Cinema Journal* 45, no. 3 (Spring 2006): 3–31.

14. In 2004, she was awarded the Presidential Medal of Freedom by President George W. Bush for her lifetime achievements.

15. From the article "Eternal Sunshine" by Nellie Mckay, www.nytimes.com/2007/06/03/books/review/McKay-t.html. See more in Tom Santopietro, *Considering Doris Day* (New York: Thomas Dunne Books, 2007).

16. Molly Haskell, *Holding My Own in No Man's Land: Women and Men and Film and Feminists* (New York: Oxford University Press, 1997), 27.

17. The name Bilitis originates from the 1894 collection of poems titled *The Songs of Bilitis* by French poet Pierre Louÿs. Louÿs claimed the poems were authored by Bilitis, a courtesan and lesbian contemporary of Sappho who lived on the Isle of Lesbos with her. The Daughters of Bilitis used the name for its obscurity, in order to maintain the organization's discretion.

18. Mackenzi Lee, *Bygone Badass Broads: 52 Forgotten Women Who Changed the World* (New York: Abrams, 2018), 167.

19. Founded in 1950, the Mattachine Society was one of the earliest gay rights organizations in the United States. The name originated from the Italian word "Mattaccino," a type of court jester who told the truth to the king when no one else dared.

20. Read more in Marcia M. Gallo, *Different Daughters: A History of the Daughters of Bilitis and the Rise of the Lesbian Rights Movement* (Emeryville, CA: Seal Press, 2007).

21. From http://www.orting.co/barbie-slogans-over-the-years/.

22. Fun fact: Barbie was an astronaut and went to the moon in 1965, four years before Neil Armstrong!

23. Barbie has had more than 120 careers in her lifetime.

24. Barbie has also been criticized for her lack of diversity. In response, Mattel has changed Barbie's body dimensions over the years and added ethnically diverse dolls as well. Its first attempt was Colored Francie in 1967, who had the same dimensions as Barbie but with darker skin. The first doll to be regarded as African American was Christie, who made her debut in 1968. In 1997, Mattel launched Share a Smile Becky, a doll in a pink wheelchair. In 2016, it came out with new body types for Barbie: tall, petite, and curvy. Learn more in Eliana Dockterman, "Barbie's Got a New Body," *Time*, February 8, 2016, time.com/barbie-new-body-cover-story/.

25. Read more in Tanya Lee Stone, *The Good, the Bad, and the Barbie: A Doll's History and Her Impact on Us* (New York: Penguin Young Readers Group, 2015).

26. To read more, see Patricia C. McKissack and Fredrick L. McKissack, *Young, Black, and Determined: A Biography of Lorraine Hansberry* (New York: Holiday House, 1998).

CHAPTER 5: 1960S

1. One of the biggest was the civil rights movement, the fight for racial equality.

2. The feminist waves metaphor was created by journalist and author Martha Weinman Lear. The "first wave" of feminism was applied retroactively to the feminists of the late nineteenth and early twentieth centuries who fought for suffrage. The "second wave" was used to describe the new feminists of the late 1960s. Martha Weinman Lear, "The Second Feminist Wave," *The New York Times*, March 10, 1968, www.nytimes.com/1968/03/10/archives/the-second-feminist-wave.html/.

3. This did not, however, solve the problem of low pay in jobs that were classed as "female."

4. Mary Wells Lawrence was the CEO of Wells Rich Greene, a creative advertising agency.

5. In simple terms, oral contraceptives work by preventing ovulation. Since no egg is produced in the woman's body, there is nothing for the sperm to fertilize, and pregnancy can't take place.

6. Enovid was actually put on the market in 1957 for the treatment of gynecological disorders, but was used off the record for birth control. It was officially marketed as a contraceptive in 1960.

7. For years, people have looked for easy and safe ways to prevent pregnancy. In 1950, Margaret Sanger (see page 19), then in her eighties, raised $150,000 to fund scientists conducting research on the first birth control pill.

8. Initially, only married women were allowed to be prescribed birth control. It wasn't until 1972 that birth control became legal for everyone, in the landmark Supreme Court case *Eisenstadt v. Baird*.

9. In the Supreme Court case *Griswold v. Connecticut* in 1965, the court overturned the state law forbidding women to use contraceptives. It deemed the law to be in violation of the right to marital privacy. Their decision ultimately allowed all women to use contraceptives.

10. According to a study by Martha Bailey, an economist at the University of Michigan, "As the pill provided younger women the expectation of greater control over childbearing, women invested more in their human capital and careers"—which ultimately contributed partially to raises in their salaries. Reported in *Live Science*, https://www.livescience.com/19338-birth-control-pill-boosted-women-wages.html. Study originally published in: Martha J. Bailey, "More Power to the Pill: The Impact of Contraceptive Freedom on Women's Life Cycle Labor Supply," *The Quarterly Journal of Economics* 121, no. 1 (February 2006): 289–320.

11. Women often take these synthetic hormones for years, which can sometimes result in hormonal disruption and compromised fertility once they choose to stop, or other physical issues such as nutrient deficiency, weight gain, depression, and changes in sexual desire. Many women are prescribed the pill for reasons other than birth control, and may not understand the health ramifications of being on contraceptives for prolonged periods of time. The medicalization of birth control also makes women reliant on the medical and pharmaceutical industries, which don't always give them all the information regarding their bodies. Read more in Jolene Brighten, *Beyond the Pill: A 30-Day Program to Balance Your Hormones, Reclaim Your Body, and Reverse the Dangerous Side Effects of the Birth Control Pill* (San Francisco: HarperOne, 2019).

12. For more criticism, read bell hooks, *Feminist Theory: From Margin to Center* (Cambridge, MA: South End Press, 1984).

13. This act established basic workers' rights, such as minimum wage and overtime pay, and prohibited most child labor.

14. As of 2017, the gender wage gap was at 20 percent! Women workers, regardless of their profession, earned on average only 80.5 cents for every dollar made by men. See more at the Institute for Women's Policy Research, https://iwpr.org/issue/employment-education-economic-change/pay-equity-discrimination/ and in The *New York Times* report on the gender pay gap: https://www.nytimes.com/2019/04/02/business/equal-pay-day.html.

15. The story is not so straightforward. Howard Worth Smith, a congressman from Virginia, included the word "sex" after being lobbied by the National Woman's Party, who thought it preposterous that black people would get labor rights before white women (see also Chapter 1, note 6). When Smith made the motion to Congress, he did so in a joking spirit, which prompted people to believe he included it as a prank. Read more in *The New Yorker*, "How Women Got In on the Civil Rights Act," https://www.newyorker.com/magazine/2014/07/21/sex-amendment

16. Quoted in Dave Zirin, "Marathon: All My Tears, All My Love," *The Nation*, April 15, 2013, www.thenation.com/article/boston-marathon-all-my-tears-all-my-love/.

17. Karen Heller, "The bra-burning feminist trope started at Miss America. Except that's not what really happened," Retropolis, *The Washington Post*, September 7, 2018, www.washingtonpost.com/news/retropolis/wp/2018/09/07/the-bra-burning-feminist-trope-started-at-miss-america-except-thats-not-what-really-happened/?utm_term=.3bbd29f8494f/.

18. Shirley Chisholm received very little support from Democratic party members or from her black male colleagues. About this she said, "When I ran for the Congress, when I ran for president, I met more discrimination as a woman than for being black. Men are men." She also received no mainstream media coverage on her campaign, which infuriated her supporters. See more in Rebecca Traister, *Good and Mad: The Revolutionary Power of Women's Anger* (New York: Simon & Schuster, 2018).

19. James Barron, "Shirley Chisholm, 'Unbossed' Pioneer in Congress, Is Dead at 80," *New York Times*, January 3, 2005, www.nytimes.

com/2005/01/03/obituaries/shirley
-chisholm-unbossedpioneer-in
-congress-is-dead-at-80.html/.

20. See the full manifesto at www.red
stockings.org/index.php/rs-manifesto/.

21. They often criticized more liberal
feminist organizations for being
merely political and not addressing
the psychological and social causes of
women's oppression.

22. One of the key ideas—and
slogans—of second-wave feminists
was that the "personal is political."
According to one understanding of
this idea, there is a direct connec-

tion between personal experiences
and the larger social and political
structures. Feminists believed that
examining the personal (for example,
in consciousness-raising groups) can
provide key insights into understanding
the political status quo. They sought to
open up their personal experiences of
oppression (within traditional gender
roles) to political discussion, and show
how the systematic oppression of
women on a personal level is one and
the same as their oppression on the
political level. In addition, they believed
that examining the personal is in and
of itself a political action. For example,
women's awareness of their feelings

toward their traditional roles in society
is the first step toward equality. As
feminist writer Carol Hanisch writes,
"One of the first things we discover in
these groups is that personal problems
are political problems. There are no
personal solutions at this time. There
is only collective action for a collective
solution." See more in Hanisch's orig-
inal essay "The Personal Is Political,"
February 1969, www.carolhanisch.org/
CHwritings/PIP.html/.

23. This was before *Roe v. Wade*, which
legalized abortion in 1973. See page 115.

24. See more at redstockings.org.

CHAPTER 6: 1970S

1. The title was changed to "Person of
the Year" in 1999. The first woman to
be featured, however, was the socialite
(and later duchess of Windsor) Wallis
Simpson, in 1936.

2. In 1972 Justice Ruth Bader Ginsburg
(1933–) became the first woman to
get tenure at Columbia Law School.
She has served as an associate justice
of the U.S. Supreme Court since
1993. RBG is the second woman to
obtain that position (after Sandra Day
O'Connor in 1981) and the first Jewish
woman to do so.

3. The Equal Rights Amendment
(ERA) is a proposed amendment to
the Constitution, which calls for com-
plete equality before the law regardless
of sex. Originally written by Alice Paul
and Crystal Eastman, it was first pro-
posed in Congress in 1923. It has since
been presented and debated several
times, but so far has failed to receive
the necessary support for ratification—
backing from thirty-eight states.
Today, there are still feminist efforts on
behalf of the ERA. For more, see Jane
J. Mansbridge, *Why We Lost the ERA*

(Chicago: University of Chicago Press,
1986) and the ERA website, www.
equalrightsamendment.org/.

4. One of the ERA's biggest oppo-
nents, Phyllis Schlafly, called for
women to return to their traditional
roles. See more in Marjorie J. Spruill,
*Divided We Stand: The Battle Over
Women's Rights and Family Values That
Polarized American Politics* (New York:
Bloomsbury, 2018).

5. Jennifer Keishin Armstrong, *Mary
and Lou and Rhoda and Ted: And All the
Brilliant Minds Who Made* The Mary
Tyler Moore Show *a Classic* (New York:
Simon & Schuster, 2013), 113.

6. It is important to note that although
the show made important feminist
strides, the portrayal of a successful
working woman such as Mary did not
exist yet for women of color.

7. By the time the show ended in 1977,
it had won twenty-nine Emmys and
spawned three spin-off series.

8. In 1973, abortion was legal in Hawaii,
New York, Washington, and Alaska. In

other states, abortion was only legal
when pregnancy occurred due to rape
or incest, or to save the life of the
mother.

9. According to *Roe v. Wade*, women
have the right to choose an abortion
during the first trimester of pregnancy.
In later stages, there are limitations
on abortion, which vary from state to
state, according to how each defines
"fetal viability"—the ability of the
fetus to survive outside the uterus.
An additional case in Georgia, *Doe v.
Bolton* (which was decided on the same
day in 1973), ruled that states could
not limit a woman from obtaining an
abortion after viability if it is necessary
to protect her health.

10. Read more about the case in this
article by the Constitution Center,
https://constitutioncenter.org/blog/
landmark-cases-roe-v-wade.

11. Norma McCorvey herself later
became a Christian and an antiabortion
activist.

12. A 2019 poll found that 61 percent
of Americans believe that abortion

should be legal in most cases. Read more in this article by Pew Research Center, https://www.people-press. org/2019/08/29/u-s-public-continues-to-favor-legal-abortion-oppose-over-turning-roe-v-wade/.

1. Read more in Doug Rossinow, *The Reagan Era: A History of the 1980s* (New York: Columbia University Press, 2015).

2. For more, read this interesting article by Bella Abzug and Mim Kaiber: "Women vs. Reagan," *New York Times*, February 12, 1984, www. nytimes.com/1984/02/12/opinion/women-vs-reagan.html/.

3. For more about the feminists' trajectory in recent decades, see Rebecca Traister, *Good and Mad.*

4. Rebecca Traister, "Rebecca Traister explains how angry women have changed politics and will shape midterms," interview by Amanda Marcotte, Salon Talks, *Salon*, October 2, 2018, audio, 24:51, www.youtube. com/watch?v=Y2P7HnZTm_E/.

5. See Chapter 6, note 3.

6. In *Webster v. Reproductive Health Services* from 1989, the Supreme Court supported Missouri state laws that highly restricted abortion, claiming they were not prohibited by *Roe v. Wade* (see page 115).

7. There was rising awareness of the wage gap at this time. As women became more educated, their salaries began to increase, and in 1987 women earned 68 cents for every dollar made by men, compared with 62 cents in 1979. From https://www.emmys.com/shows/mary-tyler-moore-show and https://www.britannica.com/topic/Mary-Tyler-Moore-Show.

CHAPTER 7: 1980S

8. In *Meritor Savings Bank v. Vinson*, the Supreme Court for the first time recognized sexual harassment as sex discrimination, in violation of Title VII of the Civil Rights Act of 1964 (see page 95).

9. In recent years, Walker has come under fire for her anti-Semitic views. See https:// www.nytimes.com/2018/12/21/arts/alice-walker-david-icke-times.html.

10. STS-7, NASA's seventh shuttle mission, lasted from June 18 to 24, 1983.

11. There are numerous books about Madonna. For a collection of personal essays about Madonna and her impact, see Laura Barcella, *Madonna & Me: Women Writers on the Queen of Pop* (Berkeley, CA: Soft Skull Press, 2012).

12. See more in this article, calling Madonna "A Real Feminist": www. nytimes.com/1990/12/14/opinion/madonna-finally-a-real-feminist.html.

13. From an interview with Geraldine Ferraro on *PBS NewsHour*, 2014, www. pbs.org/newshour/show/geraldine-ferraro-changed-politics-women, 2:45.

14. Guerrilla Girls, *Bitches, Bimbos, and Ballbreakers: The Guerrilla Girls' Illustrated Guide to Female Stereotypes* (New York: Penguin Books, 1998), 26.

15. Michael Brenson, "A Living Artists Show at the Modern Museum," *New York Times*, April 21, 1984, www. nytimes.com/1984/04/21/arts/a-living-artists-show-at-the-modern-museum.html?pagewanted=all/.

16. See MoMA's press release from the exhibit: www.moma.org/documents/moma_press-release_327370.pdf.

17. To learn more about Wilma Mankiller, read her bestselling autobiography, *Mankiller: A Chief and Her People* (New York: St. Martin's Press, 1993), and watch the 2017 documentary film *Mankiller*, www.mankillerdoc.com.

18. Kay Hymowitz, Jason S. Carroll, W. Bradford Wilcox, and Kelleen Kaye, *Knot Yet: The Benefits and Costs of Delayed Marriage in America*, The National Marriage Project, 2013, https://nationalmarriageproject. org/wp-content/uploads/2013/03/KnotYet-FinalForWeb.pdf/. See also Julia Arroyo, Krista K. Payne, Susan L. Brown, and Wendy D. Manning, "Crossover in Median Age at First Marriage and First Birth: Thirty Years of Change," National Center for Family and Marriage Research, 2013, www. bgsu.edu/content/dam/BGSU/college-of-arts-and-sciences/NCFMR/documents/FP/FP-13-06.pdf.

19. See more statistics about single women in "The Big Reversal: Single > Married" (page 180).

13. Suzanne O'Dea Schenken, *From Suffrage to the Senate: An Encyclopedia of American Women in Politics*, 2 vols. (Santa Barbara, CA: ABC-CLIO, 2000), 368.

14. In the Supreme Court case *Taylor v. Louisiana*.

15. Some women were even fired for being married, because they had the potential of getting pregnant!

1. Some criticized this wave for being too girly, individualistic, multifocal, and not politically cohesive (or angryenough) like the previous feminist waves.

2. These initial media successes problematically portray only white women. However, women of color made significant pop-culture breakthroughs in the next decades; see page 183.

3. There have been many feminist critiques against *Buffy* as well: "Buffy may be 'Barbie with a kung-fu grip,' but she is still Barbie" (Lorna Jowett, *Sex and the Slayer: A Gender Studies Primer for the Buffy Fan* [Middletown, CT: Wesleyan University Press, 2005]). Additionally, there was an issue with diversity—the show consisted of an almost entirely white cast for the duration of the series.

4. Ellen was a sitcom starring the comedian Ellen DeGeneres, whose character came out as gay in a 1997 episode of the series, shortly before DeGeneres revealed publicly that she too is a lesbian. This made Ellen the first openly lesbian actress to play an openly lesbian character on TV. In 2016, DeGeneres was awarded the Presidential Medal of Freedom by President Obama.

5. In *Harris v. Forklift Systems, Inc.*, the Supreme Court ruled, "So long as the environment would reasonably be perceived, and is perceived, as hostile or abusive, there is no need for it also to be psychologically injurious."

6. Read more in a review of Butler by Margaret Nash in *Hypatia* 5, no. 3 (Autumn 1990): 171–75, https://www.jstor.org/stable/3809989; and dive deeper in Judith Butler, *Gender Trouble: Feminism and the Subversion of Identity* (New York: Routledge, 1990).

7. For more, see Gina Fournier, *Thelma & Louise and Women in Hollywood* (Jefferson, NC: McFarland, 2007), and Becky

Aikman, *Off the Cliff: How the Making of Thelma & Louise Drove Hollywood to the Edge* (New York: Penguin Press, 2017).

8. The senate committee was led by Joe Biden, who in 2019 called Hill to apologize for his conduct during her hearings. Hill did not accept his apology. In an interview with the *New York Times* she said, "I will be satisfied when I know there is real change and real accountability and real purpose." https://www.nytimes.com/2019/04/26/us/politics/clarence-thomas-anita-hill-joe-biden.html?module=inline. For more about the case, see Rebecca Traister, *Good and Mad*, as well as the 2013 documentary *Anita*, directed by Freida Lee Mock.

9. History repeats itself: seventeen years later, in 2018, Brett Kavanaugh was confirmed as an associate justice of the Supreme Court after being accused of sexual assault.

10. See "Year of the Woman" on page 154.

11. The act permits evidence of the history of the accused offender to be introduced in court and limits evidence related to the sexual history of the accuser.

12. The four new senators were Dianne Feinstein of California, Carol Moseley-Braun of Illinois, Patty Murray of Washington, and Barbara Boxer of California. They joined Senators Nancy Kassebaum of Kansas and Barbara Mikulski of Maryland, thus tripling the number of women from two to six in the Senate.

13. Not everyone loved this declaration. "Calling 1992 the 'year of the woman' makes it sound like the 'year of the caribou' or 'year of the asparagus.' We're not a fad, a fancy, or a year," said Barbara Mikulski, senator from Maryland (1987–2017). From https://www.huffpost.com/entry/women-elected-virginias-g_b_4221967.

14. For in-depth analysis, see Michael X. Delli Carpini and Bruce A. Williams, "The Year of the Woman? Candidates, Votes and the 1992 Elections," *Political Science Quarterly* 108: 29–36. Retrieved from http://repository.upenn.edu/asc_papers/22.

15. Funding came from sources such as EMILY's List (see page 141), founded in 1985 to fund campaigns for pro-choice Democratic women.

16. As the title character states, "Whether by choice or circumstance, families come in all shapes and sizes, and ultimately what really defines a family is commitment, caring and love." From *Murphy Brown*, September 21, 1992; www.marketwatch.com/story/single-motherhood-in-america-has-soared-since-murphy-browns-feud-with-dan-quayle-2018-01-25.

17. Quayle made this comment during a speech at the Commonwealth Club of San Francisco, on May 19, 1992, and it was later quoted on the front page of the *New York Times*.

18. Throughout history, East Asian characters have also been portrayed in many cases by white or non-Asian actors in yellowface—a practice that is highly criticized today.

19. Unfortunately, it wasn't until box-office hit *Crazy Rich Asians* premiered in 2018 that American audiences were offered a major studio film with a primarily Asian cast.

20. Charles Isherwood, "The Culture Project and Plays That Make a Difference," *New York Times*, September 3, 2006, www.nytimes.com/2006/09/03/theater/03ishe.html/.

CHAPTER 9: 2000S

1. "About *Feministing*," *Feministing* (blog), feministing.com/about/.

2. Alissa Quart, "Lost Media, Found Media," *Columbia Journalism Review*, May/June 2008, archives.cjr.org/cover_story/lost_media_found_media.php/.

3. Robin Toner, "Huge Crowds in Washington for Abortion-Rights Rally," *New York Times*, April 25, 2004, www.nytimes.com/2004/04/25/politics/huge-crowds-in-washington-for-abortionrights-rally.html/.

4. One such restriction was the Partial-Birth Abortion Ban Act of 2003, which outlawed a type of procedure that removes an intact fetus from the uterus, usually performed in the second trimester.

5. Rice holds a Ph.D. from the School of International Studies at the University of Denver.

6. Women make up less than 5 percent of the CEOs of major public corporations. Read more in this illuminating article: Sheelah Kolhatkar, "Indra Nooyi and the Vanishing Female C.E.O.," *The New Yorker*, August 7, 2018, www.newyorker.com/business/currency/indra-nooyi-and-the-vanishing-female-ceo/.

7. "#11 Indra Nooyi," profile, *Forbes*, www.forbes.com/profile/indra-nooyi/#3c93ab615d6f/.

8. She was the fifth woman to become president of an Ivy League school. Only 30 percent of college presidents are women, though women account for 56.5 percent of university students.

9. Harvard graduate schools began admitting women in the late nineteenth century, but only in 1975 did the undergraduate school become completely co-ed, when Harvard and Radcliffe combined admissions offices.

10. From the Library of Congress's website: www.loc.gov/programs/john-w-kluge-center/kluge-prize/about-the-prize/.

11. The year 2008 was when Facebook, Twitter, and YouTube were first widely used to talk about feminism, and popular feminist blogs like *Feministing* (see page 167) began gaining momentum.

12. For more about online feminism, see Courtney E. Martin and Vanessa Valenti, "#FemFuture: Online Feminism," *New Feminist Solutions*, vol. 8 (New York: Barnard Center for Research on Women, 2012).

13. Heidi Brown, "The Battle of the Sexes Is Over," *Forbes*, October 16, 2009, https://www.forbes.com/2009/10/16/maria-shriver-women-america-forbes-woman-power-women-working-mothers.html#7491fad5342b/.

14. "Equal Pay Act of 1963 and Lilly Ledbetter Fair Pay Act of 2009," United States Equal Employment Opportunity Commission, www.eeoc.gov/eeoc/publications/brochure-equal_pay_and_ledbetter_act.cfm/.

15. The case was heard in 2007. Justice Ruth Bader Ginsburg wrote the dissent, and the Democratic Party proposed the act in response; it became part of President Obama's election platform. See "Ledbetter v. Goodyear Tire and Rubber Company," *Oyez*, accessed February 15, 2019, www.oyez.org/cases/2006/05-1074.

16. "Single women" includes those who never married, as well as those who are widowed, divorced, or separated.

17. "In U.S., Proportion Married at Lowest Recorded Levels," Population Reference Bureau, September 28, 2010, www.prb.org/usmarriagedecline/.

18. Independent women have historically demanded pay and job equity, lowered college costs, and other causes that benefit women. For more about the rising power of single women, see Rebecca Traister, *All the Single Ladies: Unmarried Women and the Rise of an Independent Nation* (New York: Simon & Schuster, 2016).

CHAPTER 10: 2010S

1. See more: http://msmagazine.com/blog/2016/01/05/periods-went-public-in-2015-heres-whats-next/.

2. J. A. Allen, "The Williams Sisters and the Rise of the Women's Power Game," Bleacher Report, September 28, 2012, https://bleacherreport.com/articles/1350759-the-williams-sisters-and-the-rise-of-the-womens-power-game.

3. As of 2020, Biles holds twenty-five Olympic and World Championship medals.

4. As always, there are dissenting voices here as well. Some critics see today's feminism as a "self-help" version of

feminism, in which, if a woman makes a choice that makes her feel good, it's feminist. The critics see this as a bastardization of feminism that poses a big problem for its future. They worry that feminism's new accessibility actually renders the term meaningless. For more, read Jessa Crispin, *Why I Am Not a Feminist: A Feminist Manifesto* (Brooklyn, NY: Melville House, 2017). In addition, critics argue against the commercialization of feminism, "femvertising," and the cynically capitalist use of feminism, which do not actually promote gender equality, but use it as a selling point. See more in Andi Zeisler, *We Were Feminists Once: From Riot Grrrl to CoverGirl®, the Buying and Selling of a Political Movement* (New York: PublicAffairs, 2017).

5. *The Mindy Project* was one of the first shows to star an Indian-American woman.

6. As always, there are dissenting voices here as well. Some critics see today's feminism as a "self-help" version of feminism, in which, if a woman makes a choice that makes her feel good, it's feminist. The critics see this as a bastardization of feminism that poses a big problem for its future. They worry that feminism's new accessibility actually renders the term meaningless. For more, read Jessa Crispin, *Why I Am Not a Feminist: A Feminist Manifesto* (Brooklyn, NY: Melville House, 2017). In addition, critics argue against the commercialization of feminism, "femvertising," and the cynically capitalist use of feminism, which do not actually promote gender equality, but use it as a selling point. See more in Andi Zeisler, *We Were Feminists Once: From Riot Grrrl to CoverGirl®, the Buying and Selling of a Political Movement* (New York: PublicAffairs, 2017).

7. Kali Hays, "Gloria Steinem on Feminism, Empathy and the Potential Upside of Trump," *WWD*, March 30, 2018, wwd.com/business-news/media/gloria-steinem-on-feminism-empathy-and-the-potential-upside-of-trump-1202641962/.

8. "Break Time for Nursing Mothers," United States Department of Labor, Wage and Hour Division, www.dol.gov/whd/nursingmothers.

9. This provision, as good as it is, still leaves many working mothers uncovered, as it exempts businesses with fewer than fifty employees.

10. See more in Jeffrey Ressner, "Kinetic Camera," Director Profile, Directors Guild of America, Winter 2009, www.dga.org/Craft/DGAQ/All-Articles/0804-Winter-2008-09/Profile-Kathryn-Bigelow.aspx/.

11. In 1994, the Pentagon ruled that "Service members are eligible to be assigned to all positions for which they are qualified, except that women shall be excluded from assignment to units below the brigade level whose primary mission is to engage in direct combat on the ground." Secretary of Defense memorandum, "Direct Ground Combat Definition and Assignment," January 13, 1994, www.govexec.com/pdfs/031910d1.pdf.

12. See more at Claudette Roulo, "Defense Department Expands Women's Combat Role," U.S Department of Defense, January 24, 2013, archive.defense.gov/news/newsarticle.aspx?id=119098/.

13. The Fourteenth Amendment declares that no state shall "deprive any person of life, liberty, or property, without due process of law; nor deny to any person within its jurisdiction the equal protection of the laws." Read more in Scott Bombov, "Justice Kennedy's legacy in the gay rights decisions," National Constitution Center, June 27, 2018, https://constitutioncenter.org/blog/justice-kennedys-legacy-in-the-gay-rights-decisions.

14. "About," The Women's Mosque of America, womensmosque.com.

15. The title refers to the adage "I was given lemons and I made lemonade," which Jay-Z's grandmother says at her ninetieth birthday, in a home video sampled for the album and its accompanying film. She uses it to refer to making the best of her situation, despite the hardships of being a black woman in America.

16. In "Forward" the mothers of Trayvon Martin, Eric Garner, and Michael Brown are shown holding pictures of their sons, who were killed in February 2012, July 2014, and August 2014, respectively, as a result of racial profiling and/or police brutality.

17. Beyoncé has critics too. Renowned feminist intellectual bell hooks (see page 166) publicly criticized Beyoncé as a "terrorist." She explained that Beyoncé is part of the problem by negatively influencing young girls to adhere to impossible standards of beauty. https://jezebel.com/what-bell-hooks-really-means-when-she-calls-beyonce-a-t-1573991834.

18. Many people did not like her involvement in shaping public policy while acting as First Lady, and she received a lot of negative press during that time.

19. "Mission," Onward Together, www.onwardtogether.org.

20. Some of the organizers were Teresa Shook, Evvie Harmon, Fontaine Pearson, Bob Bland, Vanessa Wruble, Tamika D. Mallory, Carmen Perez, and Linda Sarsour. Speakers included Gloria Steinem, America Ferrera, Scarlett Johansson, Angela Davis, and Tammy Duckworth. See more at www.womens-march.com.

21. Trump infamously said that when a man is a celebrity, he can pursue women sexually in any way he wants; he can even "grab 'em by the pussy." This statement was revealed to the public when an *Access Hollywood* tape from 2005 was published by the *Washington Post* on October 27, 2016.

22. The tweet was by the singer and actress Alyssa Milano, who wanted to draw awareness to the prevalence of sexual assault and harassment in America. On October 15, 2017, she posted: "If all the women who have been sexually harassed or assaulted wrote 'Me too.' as a status, we might give people a sense of the magnitude of the problem."

23. The #MeToo hashtag's popularity also started a conversation about racial politics. Many women of color felt that white and/or powerful women were dominating the conversation and the limelight while leaving out Burke, a black woman who actually deserved credit for founding "Me Too."

24. Zahara Hill, "A Black Woman Created the 'Me Too' Campaign Against Sexual Assault 10 Years Ago," *Ebony*, October 18, 2017, www.ebony.com/news-views/black-woman-me-too-movement-tarana-burke-alyssa-milano/.

25. Some of their activities include outreach in schools and connecting survivors and educators to helpful resources. One of their mottos is "empowerment through empathy." See more at metoomvmt.org.

26. According to a *Cosmopolitan* survey of 2,235 full- and part-time female employees in 2015, one in three women ages eighteen to thirty-four has been sexually harassed at work; 71 percent of those women said they did not report it. Michelle Ruiz and Lauren Ahn, "Survey: 1 in 3 Women Has Been Sexually Harassed at Work," *Cosmopolitan*, February 16, 2015, www.cosmopolitan.com/career/news/a36453/cosmopolitan-sexual-harassment-survey/.

27. This is in large part due to the "Weinstein Effect," after the film producer Harvey Weinstein, who was publicly accused by a large number of celebrity women of sexual abuse in October 2017. This engendered the #MeToo comments as well as a global trend in which women speak up to accuse famous or powerful men of sexual misconduct.

28. Learn more at www.timesupnow.com.

29. Christina Vuleta, "A Pink Wave: The Record Number of Women Heading to Congress Include Fighters, Founders, and First-Timers," *Forbes*, November 7, 2018, www.forbes.com/sites/christinavuleta/2018/11/07/a-pink-wave-the-record-number-of-women-heading-to-congress-include-fighters-founders-and-first-timers/#245e5add9873.

30. "It's Not the 'Year of the Woman.' It's the 'Year of the Women,'" CNN, November 4, 2018, www.cnn.com/2018/11/03/opinions/midterm-elections-year-of-woman-roundup/index.html. However, it is important to note that today, more than a quarter-century after the original "Year of the Woman" in 1992, women still make up just over a fifth of elected officials on Capitol Hill. This is despite comprising more than 50 percent of voters!

31. Four WOC were elected to the Senate, thirty-five to the House of Representatives, and four as U.S House Delegates to DC, Puerto Rico, American Samoa, and the Virgin Islands.

32. Rashida Tlaib from Michigan and Ilhan Omar from Minnesota.

33. Deb Haaland from New Mexico and Sharice Davids from Kansas, who is also openly gay.

34. Kyrsten Sinema from Arizona.

35. Alexandria Ocasio-Cortez, congressmember from New York, was elected when she was twenty-nine years old.

36. Sarah Kliff, "Research Shows Electing Woman Makes a Real Difference," *Vox*, www.vox.com/policy-and-politics/2018/6/27/17433986/alexandria-ocasio-cortez-beats-joe-crowley-women-elected-policy-research.

★ Sources / Suggested Reading ★

Block, Sharon, Ruth M. Alexander, and Mary Beth Norton, eds. *Major Problems in American Women's History: Documents and Essays.* 5th ed. Stamford, CT: Cengage Learning, 2014.

Butler, Judith. *Gender Trouble: Feminism and the Subversion of Identity* (New York: Routledge, 2015).

Chafe, William H. *The Paradox of Change: American Women in the 20th Century.* New York: Oxford University Press, 1991.

Chow, Rey. "Ethnicity, Fantasy, and the Film *The Joy Luck Club.*" In *Feminisms and Pedagogies of Everyday Life,* ed. Carmen Luke. Albany: State University of New York Press, 1996.

Collins, Gail. *America's Women: 400 Years of Dolls, Drudges, Helpmates and Heroines.* New York: William Morrow, 2003.

When Everything Changed: The Amazing Journey of American Women from 1960 to the Present. New York: Little, Brown, 2009.

Dicker, Rory. *A History of U.S. Feminisms.* Berkeley, CA: Seal Press, 2016.

Dubois, Ellen Carol, and Lynn Dumenil. *Through Women's Eyes: An American History with Documents.* New York: Bedford/St. Martin's, 2015.

Engelman, Peter C. *A History of the Birth Control Movement in America.* Santa Barbara, CA: Praeger, 2011.

Evans, Sara. "Women in American Politics in the Twentieth Century." The Gilder Lehrman Institute of American History. Accessed at http://ap.gilderlehrman.org/history-by-era/womens-history/essays/women-american-politics-twentieth-century.

Felder, Deborah G. *A Century of Women.* New York: Citadel Press, 2003.

Friedan, Betty. *The Feminine Mystique.* New York: Norton, 1963.

Goodwin, Joanne L., ed. *Encyclopedia of Women in American History.* New York: Routledge, 2002.

Guerrilla Girls. *Bitches, Bimbos, and Ballbreakers: The Guerrilla Girls' Illustrated Guide to Female Stereotypes.* New York: Penguin, 1998.

Hartmann, Susan M. *The Home Front and Beyond: American Women in the 1940s.* Boston: Twayne, 1984.

Haskell, Molly. *Holding My Own in No Man's Land: Women and Men and Film and Feminists.* New York: Oxford University Press, 1997.

hooks, bell. *Feminism Is for Everybody: Passionate Politics.* New York: Routledge, 2000.

Feminist Theory: From Margin to Center. Cambridge, MA: South End Press, 1984.

Hymowitz, Carol, and Michaele Weissman. *A History of Women in America: From Founding Mothers to Feminists.* New York: Bantam Books, 1978.

Lee, Mackenzi. *Bygone Badass Broads.* New York: Abrams, 2018.

Lepore, Jill. *The Secret History of Wonder Woman.* New York: Alfred A. Knopf, 2014.

Ogden, David C., and Joel Nathan Rosen, eds. *A Locker Room of Her Own: Celebrity, Sexuality, and Female Athletes.* Jackson: University Press of Mississippi, 2013.

Rich, Doris L. *Amelia Earhart: A Biography.* Washington, DC: Smithsonian Institution, 1996.

Schatz, Kate. *Rad American Women A–Z.* San Francisco: City Lights, 2015.

Schenken, Suzanne O'Dea. *From Suffrage to the Senate: An Encyclopedia of American Women in Politics.* 2 vols. Santa Barbara, CA: ABC-CLIO, 2000.

Shetterly, Margot Lee. *Hidden Figures: The American Dream and the Untold Story of the Black Women Mathematicians Who Helped Win the Space Race.* New York: William Morrow, 2016.

Spruill, Marjorie J. *Divided We Stand: The Battle Over Women's Rights and Family Values That Polarized American Politics.* New York: Bloomsbury, 2018.

Traister, Rebecca. *All the Single Ladies: Unmarried Women and the Rise of an Independent Nation.* New York: Simon & Schuster, 2016.

Good and Mad: The Revolutionary Power of Women's Anger. New York: Simon & Schuster, 2018.

Walker, Alice. *In Search of Our Mothers' Gardens: Womanist Prose.* Orlando, FL: Harcourt, 1983.

Zeisler, Andi. *We Were Feminists Once: From Riot Grrrl to CoverGirl®, the Buying and Selling of a Political Movement.* New York: PublicAffairs, 2017.

★ Acknowledgments ★

THANK YOU TO ALL THE AMAZING WOMEN WHO
CONTRIBUTED TO MAKING THIS BOOK.

———

Thanks to Alli Brydon, who helped shape it from the very beginning,

to Ellen Weinstein for her insightful comments and feedback on the early stages of the art,

to Anne Moore Armstrong for keeping things together and for all her support,

and to my talented friends Maya Ish-Shalom and Eugenia Mello, who gave the best art and design advice.

———

Thanks to my MFA friends and teachers at SVA who gave me a home to begin working on this project.

Thanks to the incredible team at Abrams—Ashley Albert, Madeline Jaffe, Diane Shaw, and Emma Jacobs—who worked so hard and patiently through all the stages to make a beautiful book.

Thank you to all my family for being there: to my parents and siblings for their encouragement, to my daughters for inspiring me every day, and to my wonderful (and feminist!) husband, Yitz, for his unwavering support and love.

And finally, thank you to all the inspiring women throughout history!

★ Index ★

A

abortion, 125, 210nn8–12

 protests for, 104, 109

 restrictions, 170, 213n4

 Roe v. Wade on, 107, 115

accessibility, of feminism, 165, 166, 167, 175, 213n4, 214n6

Addams, Jane, 32, *33*, 205n2

African American women, 17, *51*

 "American Dream" and, 69

 in Congress, 103, 156

 NCNW championing, 42

 in Olympics, 66

 in WWII, 57

League of Their Own, A (film), 59

Alexander, Sadie Tanner Mossell, *15, 16*, 17

All-American Girls Professional Baseball League (AAGPBL), 59, *60–61*

American Birth Control League (ABCL), 19

American Civil Liberties Union (ACLU), 107, 170

"American Dream," 69

American Medical Association, 14, 44

American women, 8–9, 13, 203. *See also* women

 breastfeeding, 82, 214n9

 in Congress, 145, 154, *155, 200*, 201

 jury service and, 120, *121*

 as "Man of the Year," 107

 marriage and, 142, *143*, 180, 181

Anthony, Susan B., 13, 204n4, 204n7

antiabortion, 109, 125, 210n8

Asian American women, 158, *159*, 204n5

B

baby boom era, 47

Bailey, Martha, 209n10

Barbie doll, 83, *83*, 208nn22–24

baseball, 59, *60–61*, 207n19

"Battle of the Sexes," 116, 176, *177*

Beloved (Morrison), 161

Bethune, Mary McLeod, 42, *42*

Bigelow, Kathryn, 186, *187*

bikinis, 47, 206n4

Biles, Simone, 183, 213n3

birth control, *18*, 19, 88, 205n14

 legalization of, 44, 209nn8–11

 Sanger and, 44, *44*, 204nn11–13

black feminism, 135

Black Lives Matter movement, 193, 214n16

Bluest Eye, The (Morrison), 161

Boston Marathon, 98, *98*, 99

Bow, Clara Gordon, 27, *27*

"bra burners," *100*, 101, 209n17

Braun, Carol Elizabeth Moseley, 156, *156*

breastfeeding, 82, 214n9

Broadway, Hansberry and, 84

Browder v. Gayle, 207n10

Brown, Helen Gurley, 91

Buffy the Vampire Slayer (TV show), 145, 212n3

Burke, Tarana, 198, 215nn23–24

Bush, George W., 170, 171, 208n14, 212n4

bus segregation, 77, 207n10

Butler, Judith, 147

C

Caldwell, Sarah, 122, *122*

capitalist consumer culture, 69

Caraway, Hattie Wyatt, 36, 37

Carter, Jimmy, 126, 127

CEOs of major corporations, 107, 172, 213n6

Chicana community, 112

Chisholm, Shirley, *102*, 103, 209n18

civil liberty movements, 87, 208n1

Civil Rights Act (1964), 95

civil rights movement, 77, 84

Clinton, Bill, 138, 194

Clinton, Hillary, 194, *194, 202*

Coachman, Alice Marie, 66, *67*

Coast Guard Women's Reserve (SPARS), 57, 207n16

Coca-Cola, Evans leading, 40

Cold War, 51, 69, 89

Colvin, Claudette, 207n10

Comision Femenil Mexicana Nacional (CFMN), 112

Congress (US), 107, 127

African American women in, 103, 156

American women in, 145, 154, *155*, *200*, 201, 212nn12–15

conservatism, *64*, 65, 69, 78

constitutional amendments, US. *See specific amendments*

Coolidge, Calvin, 26

Cosmopolitan magazine, 91, 215n26

counterculture, 87

Crazy Rich Asians (film), 212n19

critics, of feminism, 213n4, 214n6, 214n17

"cult of domesticity," 71

cultural perspective

"Battle of the Sexes" and, 176

on sexuality, 75

D

Daughters of Bilitis (DOB), 80, *80*, 208n17

Day, Doris, 78, *79*, 208n14

digital media, 175

discrimination, 119, 179, 204n5. *See also* sexual discrimination

Chisholm on, 102, 209n18

against LGBTQAI, 81

Distinguished Flying Cross, 35

diversity, 62, 69, 201, 208n24

domesticity, 69, *70*

Doyle, Geraldine Hoff, 206n13

Dylan, Bob, 87

E

Earhart, Amelia, 29, *34*, 35, 39

Ederle, Gertrude Caroline, *24*, *25*, 26, 205n19

Ellen (TV show), 145, 212n4

EMILY's List, 141, 212n15

employment rates, 29, 47

English Channel, 26

Enovid ("the pill"), 88, 209n6

Ensler, Eve, 162

Equal Credit Opportunity Act (ECOA) (1974), *118*, *119*

equality, in the workplace, 179

Equal Pay Act (EPA) (1963), 87, 94, 179, 208n3, 209n13

Equal Rights Amendment (US Constitution), 210nn3–4

Evans, Lettie Pate Whitehead, 40, *41*

F

Fair Labor Standards Act (2010), 94, 185, 209n13, 214n9

Family and Medical Leave Act (FMLA) (1993), 123

family planning, 88, 142, *143*

family values, 157, 176

Farnham, Marynia F., 65

fashion, 11, 21, 27, 47

Faust, Drew Gilpin, 173, *173*, 213n8

Felton, Rebecca Latimer, 204n2

female empowerment, 54, 162

in film and TV, 72, 108, 148, 186

female mathematicians, 51

Feminine Mystique, The (Friedman), 93, 109

Feminine Psychology (Horney), 45

feminism. *See specific topics*

Feminism Is for Everybody (hooks), 166

Feministing blog, 167, *167*, 213n11

Ferraro, Geraldine, 134, *134*

film and TV, 157, 183

Asian American characters in, 158, 212nn18–19

female empowerment in, 72, 108, 148, 186

"first lady of civil rights," 76, 77

"First Lady of the Struggle," 42

first-wave feminism, 13, 208n2

Flapper, The (magazine), 21, 205n16

flapper(s), 21, *21*, 205n17

foremothers, 9

Fourteenth Amendment (US Constitution), 115, 214n13

fourth-wave feminism, 165, *174*, 175, 213n11–12

Fox, Annie Gayton, 58, *58*

Fraley, Naomi Parker, 206n13

freedom, through fashion, 11, 27

Freedom newspaper, 84

Freud, Sigmund, 45

Friedan, Betty, *92*, 93, 109

G

gay marriage, 183, 190

gender, as social construct, 147

gender equality, 116, 179, 203

ECOA and, 119

in military, *188*, 189, 214n11

gender reassignment, 74

gender roles, 71

 after WWII, 69

 in military, 47, 57

Gender Trouble (Butler), 147

General Electric Company v. Gilbert, 123

Ginsburg, Ruth Bader, 107, 210n2, 213n15

gold medal winner, 66

Gone with the Wind (Mitchell), 43, *43*, 205n12

Graham, Katharine, 107

Great Crossover, the, 142, *143*

Great Depression, 29, 31, 69

Griswold v. Connecticut, 209n9

H

Hanks, Tom, 59

Hansberry, Lorraine, 84, *85*

Harvard University, 173, *173*, 213n9

Hazel Scott Show, The, 72, 207n2

Hefner, Hugh, 75

Hidden Figures, 51

Hill, Anita, 152, *153*, 212n8

homosexuality, after WWII, 81

hooks, bell, 166, *166*, 214n17

Hoover, Herbert, 35

Horney, Karen, 45

Hughes, Dorothy Pitman, 113

Hull-House, social welfare of, 32

Hurt Locker, The, 186

I

independence, in fashion, 21

independent women, 21, 71, 108, 180, 213n18

In Search of Our Mothers' Gardens (Walker), 128

International Congress of Women, 32

Internet, the, 165–67, 175

intersectionality, 135, 145, 175

J

Jazz Age, party women of, 11, 21

Johnson, Lyndon B., 95

Jorgensen, Christine, 74, *74*

Joy Luck Club, The (film), 158

jury service, 120, *121*, 211n14

K

Kennedy, John F., 89, 94

Khouri, Callie, 148

King, Billie Jean, 116, *117*

King, Martin Luther, Jr., 77

Knowles-Carter, Beyoncé, 113, 183, 193, 214nn15–17

Kotex pads, 20, *20*, 204nn14

L

The Ladder, 81, 84

La Leche League International (LLLI), 82, *82*

Langley Memorial Aeronautical Laboratory, 51

Lear, Martha Weinman, 208n2

Ledbetter v. Goodyear Tire & Rubber Company, 179, 213n15

Lemonade, *192*, *193*, 214n15, 214n16

lesbian civil and political rights, 80, *80*, 81, 84

LGBTQAI community, 81, 183, 197

liberal feminism, 113, *113*

Lilly Ledbetter Fair Pay Act (2009), *178*, 179

Lincoln, Abraham, 205n18

Lindbergh, Charles, 205n4

Lorde, Audre, 135, *135*

Lundberg, Ferdinand, 65

M

Madonna, 132, *133*

Madrigal v. Quilligan, 112

Malcolm, Ellen R., 141

Malcom X, 193

"Man of the Year," 107, 210n1

March for Women's Lives, *168*, *169*, 170

Marine Corps Women's Reserve (WR), 57

marriage, 180, *181*

 motherhood before, 142, *143*

 sexuality and, 183, 190

Marston, William Moulton, 53, 206n12

Mary Tyler Moore Show, The, 108, 210nn6–7

Mattachine Society, 208n19

McCorvey, Norma, 115, 210n11

Mead, Margaret, 207n24

menstruation, 20

#MeToo movement, 198, *199*, 201, 214nn22–27

Metropolitan Opera, 122

Mexican American women, 112

military, women in, 47, 57, *188*, 189, 214n11

millennial feminism, 183

Miller, J. Howard, 54

The Mindy Project, 183, 214n5

Mint metal, Ross on, 23

Mitchell, Margaret, 43

Modern Woman (Lundberg and Farnham), 65

money, gender equality and, 119

Moore, Mary Tyler, 108, *108*

Morrison, Toni, *160*, 161

mosque, for women, 191, *191*

motherhood, 69, 82, 88

in film and TV, 157

before marriage, 142, *143*

women workers and, *184*, 185

Motherhood in Bondage (Sanger), 206n12

"mother of social work," 32

Ms. magazine, 113, *113*

Murphy Brown (TV show), 157, *157*, 212n16

"Music's Wonder Woman," 122

Muslim community, 191

N

National Academy of Sciences, 22, 205n18

National Association for the Advancement of Colored People (NAACP), 77, 208n11

National Council of Negro Women (NCNW), 42

National Woman's Party, 35

National Women's History Month, 127

National Women's History Week, 126, *126*

Native American women, 201, 204n5

New Ways in Psychoanalysis (Horney), 45

New York City Marathon, 99

New York Daily News, 74

New York Times, 158, 162

9/11, 165

Nineteenth Amendment (US Constitution), 11–13

Nobel Peace Prize, 32

Nobel Prize in Literature, 161

Nooyi, Indra, at PepsiCo, 172, 172

"nuclear family," 69, 207n1

O

Obama, Barack, 161, 179, 190, 194, 213n15

Obergefell v. Hodges, 190

O'Connor, Sandra Day, 125

Olympics, 66, 205n19

opera, 122

oral contraceptives, 88, *88*, 208nn5–10, 209n11. *See also* birth control

P

Parks, Rosa, 76, 77, 208n11

Partial Birth Abortion Ban Act (2003), 213n4

patriotism, motherhood and, 69

Paul, Alice, *12*, 13, 204n6

Pearl Harbor, Japan bombing, 58

PepsiCo, Nooyi at, 172, *172*

"the pill" (Enovid), 88, 208nn5–9. *See also* oral contraceptives

Pink Wave, 201

Planned Parenthood Federation of America, 19, 170

Plath, Sylvia, 62

Playboy magazine, 75, 75

political pioneer, 141

political pioneers, 23, 134, 171

postfeminism, 125

Powell, Adam Clayton, Jr., 72, 207n3

pregnancy, 123, 210nn8–9

Pregnancy Discrimination Act (PDA) (1978), 123, *123*

presidential nominee, 103

President's Commission on the Status of Women (PCSW), 89

pro-choice, 141, 170, 212n15

propaganda, WWII for, 57

protests, for abortion, 104, 109

Pulitzer Prize, the, 43

punk movement, 151

Purple Heart, Fox receiving, 58

Q

Quayle, Dan, 157, 212n17

queer identity, 147, 165, 175

R

racial equality, 51, 72

bus segregation and, 77

Civil Rights Act and, 95

women's rights and, 42

radical feminism. See Redstockings

Raisin in the Sun, A (Broadway play), 84

Rankin, Jeannette, 14

Reagan, Ronald, 125, 134

Redstockings, 104, *105*

Rhimes, Shonda, 183

Rice, Condoleezza, 171, *171*, 213n5

Richards, Mary, 108

Ride, Sally, 125, *130*, 131, 211n10

Right to Fight, *188*, 189, 214n11

"right to privacy," 115

right to vote, 8, 11–13, *12*

Riot Grrrls, *150*, 151

Roaring Twenties, 10–11, 27

Roe v. Wade, 107, 114, 115, 210n9

Roosevelt, Eleanor, 29, *38*, 39, 89, *89*, 205n7

Roosevelt, Franklin D., 23, 39, 51

Rosie the Riveter, 54, *55*, 206n13, 207n14

Ross, Nellie Tayloe, 23, *23*

S

Sabin, Florence, 22, *22*

same-sex marriage, 190, *190*

Sanger, Margaret, 18, 19, 53, 205n14, 206n15

 birth control efforts of, 44, 204n11

Sargent, Aaron A., 13

Schlafly, Phyllis, 210n4

Scott, Hazel, 72, *73*

second-wave feminism, 71, 87, 93, 208n2, 210n22

Senate (US), Caraway in, 36

Seventeen magazine, 62, *63*

Sex and the City (TV show), 145

Sex and the Single Girl (Brown), 90, 91

sex education, on birth control, 19

sexual assault, 198, 203, 211–12n8, 214n22

sexual discrimination, 211n7

 ECOA against, *118*, *119*

 EPA against, 94

 PCSW reporting, 89

 PDA and, 123

 Title VII prohibiting, 87, 95

sexual harassment, 87, 125, 145, 152, 198, 211n5, 211n7, 214n26

sexuality, 75, 116, 183, 190

sexual revolution, 69, 88

Sheppard–Towner Maternity and Infancy Act (1921), 14

single women, 180, 213nn16–17

Sister Outsider (Lorde), 135

social ills, feminism blamed for, 65

social media, 165, 175, 212n11

social welfare, 14, 32

space travel, Ride and, 131

Stanley, Winifred C., 94

Starr, Ellen G., 32

Steinem, Gloria, 9, 107, 113

sterilization, 112, *112*

suburbanism, 69

suffrage, 11, 13. *See also* right to vote

Supreme Court. *See also specific cases; specific topics*

Switzer, Kathrine, 98–99

T

Tan, Amy, 158

teenage girls, 62

tennis, 116, *117*, *183*

Thelma & Louise (film), 148, *149*

third-wave feminists, 75, 145, 211n1

Thomas, Clarence, 152

Time, 107

Time's Up movement, 198, 201

Title VII (US Constitution), 87, 95

To Be Young, Gifted and Black (play), 84

Tompson, Marian, 82

transgender, Jorgensen as, 74

Trump, Donald, 194, 197, 215n21

U

unequal pay, 94, 125, 209n14

U.S. v. One Package, 44

V

Vagina Monologues, The (play), 162, *163*

Valenti, Vanessa, 167

Valentine, Helen, 63

Vanity Fair, 27

violence

 civil rights, 77, 207n8

against women, 145, 151, 152, 162, 183, 198

Violence Against Women Act (1994), 152, 212n11

W

Walker, Alice, 128, *129*, 211n9

Walters, Barbara, 107

Washington Post, 107

Weinstein, Harvey, 215n27

What Happened (Clinton, H.), 194

White, Mary, 82

Williams, Serena, 183

Wilson, Woodrow, 13

Winfrey, Oprah, 161

womanism, 128

women, *30. See also* American women

 independent, 21, 71, 108, 180, 213n18

 in military, 47, 57, *188*, 189, 214n11

 violence against, 145, 151, 152, 162, 183, 198

Women Accepted for Volunteer Emergency Service (WAVES), 57

Women Airforce Service Pilots (WASP), 57

women "computers," 51

women of color, 128, 212n2, 215n31. *See also specific ethnic groups*

 film and TV created by, 183

 postfeminism and, 125

Women's Army Corps (WAAC/WAC), 57, 207n15

Women's Division of the National Democratic Committee, 23

Women's International League for Peace and Freedom, 32

women's liberation movement

 "bra burners" and, *100*, 101

 in Congress, 107

 Redstockings and, 104

Women's March, the, *196*, 197, 214n20

Women's Peace Party, 32

women's rights, 8, 13, 107, *202*

 in Great Depression, 29

 racial equality and, 42

Women's Strike for Equality, 109, *110*, *111*

women workers, 96, 97, 206n6

 in Cold War, 89

 discrimination against, 87

 employment rates of, 47

 family values and, 176

 gender equality and, 179

 laws preventing, 205n1

 motherhood and, *184*, 185

 sexual harassment case, 145, 152

 WWII and, 47, *48*, *49*, 50, 54, 56, 206n1, 206n3

Wonder Woman, *52*, 53, 206nn9–12

workplace

 equality in the, 179

 sexual harassment in the, 87, 125, 145, 152, 198, 212n5

World War I (WWI), 13

World War II (WWII), 47, 206nn13–14

 AAGPBL and, 59, *60–61*

 African American women in, 57

 conservatism after, 65, 69

 female mathematicians in, 51

 homosexuality after, 81

 propaganda for, 57

 second-wave feminism after, 71

 women workers and, 47, *48*, *49*, 50, 54, 56

Wrigley, Philip, 59

X

Xena: Warrior Princess (TV show), 145

Y

"Year of the Woman," 154, 212nn13–15, 215n30

★ About the Author ★

———

Aura Lewis is an author and illustrator based in New York City. She has an MFA in illustration from the School of Visual Arts. Lewis is also the author and illustrator of *Gloria's Voice*, a picture book about feminist icon Gloria Steinem.